The
FOCALGUIDE
to
Close-ups

THE ⓕ FOCALGUIDES TO

The FOCALGUIDE to Close-ups

Sidney Ray

Focal Press · London

Focal/Hastings House · New York

🕮 British Library Cataloguing in Publication Data

Ray, Sidney F
 The focalguide to close-ups.
 1. Photography, Close up—Amateurs' manuals
 1. Title
 778.3'24 TR683

 ISBN (excl. USA) 0 240 50979 X
 ISBN (USA only) 0 8038 2336 3

 First edition 1978
 Second impression 1979

Printed in Great Britain by
Thomson Litho Ltd, East Kilbride, Scotland

Contents

Introduction

To most people the camera acts as a form of illustrated notebook to record aspects of their lives and those of their family and friends. Examination of the pictures taken would show that most of them could be classified into one of three groups, namely *faces, places* and *things.* The first two are predominantly family groups and events, together with holiday locations and scenes, and they provide a wonderful stimulus to the memory.

The third group of *things* covers almost all other subjects and is a strong reflection of the photographer's other interests and hobbies, covering items from steam trains to match box labels. Often restrictions on the space available, size of the subject, rarity and cost mean that the hobbyist is limited to collecting photographs of his interests. In fact, there are many amateur photographers who specialize in collecting with the camera and would never dream of wanting to own the subject matter. Subjects chosen are as diverse as sundials, inn signs, wild flowers, railway bridges and lamp-posts. Inevitably there soon comes a time when a simple record photograph is inadequate or unsatisfactory. Many items are small and do not show enough detail in a conventional photograph taken at the closest focusing distance of the camera. In addition, larger objects may possess interesting or intricate detail that make ideal mini-subjects.

All these needs can only be met by some form of close-up photography. In its simplest sense it can be described as any technique which enables you to take pictures with the subject closer than the normal near distance of the unaided camera lens.

But once these techniques are used and mastered, they can be found to have a fascination and interest all of their own. One person may find all he desires from a pastime in the steady acquisition, fabrication and mastery of manipulation of all the various bits of hardware available for close-up photography. Another person

10

may use a simple standardized technique to record his prize blooms or garden produce. Yet another may find pleasure in collecting photographs of small antiques with all details clearly resolved, that normally would only be seen by tedious inspection with a hand magnifier. Yet another may use close-up techniques to produce abstract and puzzle pictures of the 'guess what this is?' type.

It is obvious from a casual inspection that close-up photographs are often used in illustrating books and magazines. Advertisements are an excellent example, for while many are conventional pack shots merely showing the shape, size and cosmetic details of a subject, most others feature a telling detail of the subject in close-up. The visual impact of a large close-up in colour, skilfully lit, can be most appealing, even though the subject is as mundane as a wedding ring or shirt cuff or as unusual as an integrated circuit.

But while most photographers acknowledge the particular interest and pleasure of a close-up photograph, many have an initial form of shyness in approaching close to a subject. Instead they prefer to frame it with plenty of surround or background, and thus obtain disappointing photographs. Conversely, many other inexperienced photographers are unhappy at the unsharp pictures obtained when they bring the camera too close to the subject. Perhaps they did not realize that the sharp image in the bright-line viewfinder does not indicate that the subject is also in focus. This book is written to help both of these groups and all the others who wish to produce satisfying close-up photographs.

All types of camera, from the 'point and shoot' variety to more sophisticated models, can be used to take close-up pictures. Methods of operation are explained for all these camera types.

While the requirements of the scientist or professional user for close-up photography may be very different from the amateur photographer, the latter must not be daunted by the lack of specialist equipment. He can still take excellent pictures within the limitations of his equipment.

This then is the starting point, ownership of a camera of any type and a wish to explore the world of the close-up photograph.

The Scope of Close-Up Photography

The fascination of detail

The mind is always fascinated by the small individual areas of a subject which can often be of more interest than the whole and which may contribute greatly to the overall visual impression. Detail may consist of almost anything, including the surface texture or finish, small components or individual parts and the relationship of these to the subject.

In order to see this detail, you must look more closely at the subject and concentrate the gaze upon smaller and smaller areas. This is done by approaching closer to the subject or alternatively, by bringing the subject closer to the eyes.

The unaided eye

The unique and interesting properties of human vision vary considerably from one person to another, and any general discussion about human vision refers to someone who has normal sight. The following comments refer to this average viewer.

The eye focuses at close distances by a muscular mechanism known as *accommodation,* involving an internal focusing action of the lens in the eye. When the eye is focused on infinity it is in a relaxed state with little muscular activity. Then when there is a need to focus close, the lens of the eye is altered by muscular action to give sharp vision at the required distance. The closest distance of sharp vision for the average adult is taken as being approximately 25 cm (10 inches), but is less for young children and greater for elderly people.

The loss of focusing ability that occurs with advancing age and individual defects of vision such as short sight may be corrected by the use of spectacles.

The smallest detail that can be resolved in good light conditions at this distance of 25 cm for a subject with a reasonable amount of contrast is about one tenth of one millimetre across. But the nature of the subject matter itself, poor light, visual defects or fatigue can reduce this average value considerably. In addition, the subject detail is seen only very sharply in the very centre of the field of view and falls off rapidly at the edges. It is also fatiguing to concentrate and study closely at such distances. The answer to such problems is to use a visual aid such as a hand magnifying glass or a low power microscope.

The simple magnifier

The magnifier or hand lens has been in use for a very long time and is found in most households. In its simplest form it is a single element glass or plastic lens of biconvex shape and of fairly large diameter (see page 15). It is a positive lens since it forms an image of a distant object on a piece of paper held behind the lens. This can be shown by using the sun as the object and burning the paper by focusing the sun's energy with the lens.

The *focal length,* which largely determines the magnifying power of this simple lens may be taken as the distance from the centre of the lens to the sharp image when the lens images a distant object, such as the sun. A typical value may be 50 mm (2 inches). Small objects at this distance of 50 mm or less may be seen by the eye as an enlarged image at a distance of 250 mm with the aid of this magnifier (see page 15). Dividing this distance of 250 mm by the focal length of 50 mm then gives the approximate magnifying power of the lens as X5.

This portable tool reveals a whole new world of detail at a low cost. But, just like the unaided eye, only a small central portion is really sharp and clear. The remainder has severe colour fringes and progressively worsening distortion towards the edges. The extent of subject sharpness (depth of field) is also small and any hand tremors or subject movement can be frustrating.

It is obvious that close-up photography is the ideal way of recording such subject detail to give a permanent record which may be studied at leisure as often as desired without fatigue.

Before looking at this claim in more detail it is worth mentioning that many photographers already have a very high quality and high power magnifier in the form of their standard camera lens, provided that it is removable, of course. A 50 mm *f*2 lens acts as an excellent magnifier and can be used in the hand to study a subject in detail to see if photography is worthwhile. It is easier to view the subject this way than by moving the whole camera plus close-up attachments.

Use of a camera

The painstaking recording of detail is the ideal application of the camera and almost all of the objections in the use of a hand magnifier are thereby overcome. A good quality camera lens will record detail over its whole field of view with almost identical resolving power, not just sharp in the middle. When the lens is stopped down to a small aperture the depth of field obtained is often adequate to render the whole subject sharply in focus. The use of a tripod removes tremor, and a moving subject may be frozen to clarity by use of electronic flash as the light source. A long exposure time can be given to record details barely visible to the eye by virtue of the accumulative light gathering power of the film.

The larger, sharp field of view in the photograph as compared with the eye can be studied and appreciated at leisure. It is sometimes quite overwhelming to view in a projected slide or print the wealth of detail that just was not perceived by the eye at the time of exposure, either by looking directly at the subject or through the viewfinder.

Camera close-up

The recording of small subjects and small areas of larger subjects to best fill the film area, means that the camera is taken close to the subject. This proximity of the camera to the subject gives rise to the general term of *close-up photography*. Like most other specialized subjects, close-up photography has its own jargon which needs explanation. Some of the more important terms will now be introduced and explained.

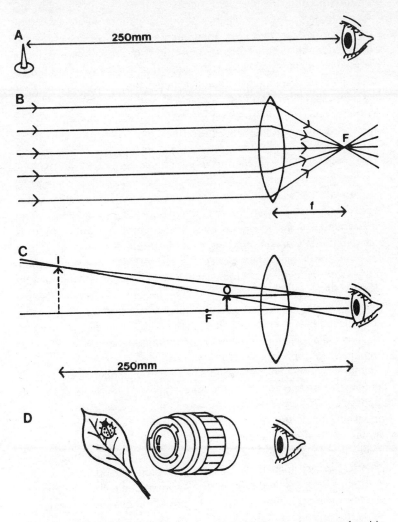

Close-up vision and magnifiers. A. The unaided eye can focus comfortably down to about 250 mm (10 in). B. A simple positive lens (magnifying glass) brings light from a distant object to a focus F behind the lens. Distance *f* is the focal length. C. Using a simple magnifying glass with the subject 0 positioned inside the focus F gives a magnified image I which is located 250 mm away. D. A camera lens taken off the camera and used reversed may be used as a high quality magnifier.

Close-up focusing

The camera lens forms an inverted and reversed image of the subject, which is then recorded by the film. This image is made sharp and clear by focusing the lens; an action which involves changing the distance of the lens from the film.

Leaving aside the fact that a camera lens is of complex optical construction, for simplification we may consider it as a thin simple lens. The necessary distance from the lens to film to give a sharp image depends in the first instance on the distance of the subject from the lens. For a subject at a great distance or *infinity,* the lens to film distance is at its minimum value. This latter distance is defined as the focal length of the lens (see page 15). As the camera approaches the subject, the lens to subject distance decreases and the lens to film distance increases. Initially only a slight increase is needed as the subject approaches to a couple of metres or so, but then as the subject gets closer, the lens to film distance rapidly increases. In fact, when the subject is two focal lengths distant from the lens, the lens to film distance (focusing extension) is also two focal lengths. These values have some practical significance as the subject is rendered at same size on the film. At greater subject distances than this the image is smaller than life-size, and at closer distances it is larger than life-size.

The lens to subject distance and lens to film distance are sometimes called the object and image conjugate distances respectively. A particular mathematical relationship exists between them and the focal length of the lens; this formula can be useful in practical situations, see data section.

So a short lens to subject distance, i.e. a close-up, will give a large size image provided that the lens is sufficiently distant from the film. This lens to film distance is still sometimes called the *bellows extension,* a term derived from the construction and operation of early plate cameras. Some of these cameras were specified as having double extension bellows meaning that life-size images were possible without additional aids.

The size of the image of the subject on the film is usually referred to in terms of *image magnification* or *scale,* and is used in calculating depth of field and exposure correction factors.

Image magnification

The idea of magnification of a subject by optical methods is familiar to most people. Almost everyone has at some time used a telescope or binoculars to obtain a larger image of a distant subject and is aware that binoculars specified as being of X8 power gives an image eight times larger than that given by the naked eye, or, makes the subject appear to be at one eighth of its actual distance.

Magnification, m, may be defined as the ratio of the image size, I, to the corresponding object size, O, so that $m = I/O$. In the case of a telescope or binoculars its value is always equal to one or more.

Photography uses the same definition of magnification, but almost always gives a value of less than one, often only a very small fraction. This is understandable when a vast sized subject such as a landscape has to be encompassed within a small negative area of say 24 × 36 mm, as produced by a 35 mm camera. As an example, the image magnification given by a standard 50 mm focal length lens on a 35 mm camera focused at its closest distance of one metre (3 feet) has a value of 1/19 or 0.053.

Note that both fractional and decimal notation can be used to specify magnification. This value can also be used to calculate the minimum subject area covered by the lens, and at this setting of $m = 1/19$ the area is nominally 456 × 684 mm (19 × 28.5 inches). These figures are obtained by multiplying the dimensions of the negative (24 × 36 mm or 1 × 1.5 inches) by the denominator, 19, of the magnification fraction, or by dividing these values by the decimal magnification. It can be seen that this is quite a large area compared with the sizes of many close-up subjects.

Reducing the subject distance to 0.5 metre (20 inches) with the same camera gives a magnification of 1/9 or 0.11 and a corresponding subject area of 216 × 324 mm (9 × 13.5 inches).

Because photography is concerned with producing images which are faithful reproductions of the original subject, another term which is often used instead of magnification is that of *reproduction ratio*, which is the image size to object size expressed as a ratio. For example, in the two cases above, the reproduction ratios would be 1:19 and 1:9 respectively.

So, to sum up for a camera giving an image one quarter life-size, this may be expressed in figures as a magnification or scale of 1/4 or 0.25 or alternatively at a reproduction ratio of 1:4. Note that a ratio of 4:1 denotes a photographic reproduction of four times life-size or magnification of 4.

These magnification values all refer to the image on the film in the camera. Subsequent enlargement of the negative or projection of a colour transparency gives a final reproduction of the subject at a greater magnification.

For example, a subject photographed at a magnification of 0.2 giving a negative which is then enlarged five times linearly, gives a print which reproduces the subject as life-sized. This is because the product of the two magnifications or 0.2 and 5.0 is equal to 1.0. It is often important to state this final magnification in the photograph so that there is some idea of the original size. Alternatively, inclusion of a suitable graduated scale in the picture area may be possible. A useful technique for the unusual subject, is to include as a comparison some well known object whose size is familiar to all, such as a matchstick or a coin or even the tips of the fingers. Occasionally, for reasons such as lens performance or depth of field or lighting, it may be necessary to obtain the final desired magnification in two such stages, as a single stage process may give unsatisfactory results.

Determination of magnification

Many circumstances and techniques in close-up photography demand that the magnification is known. This value is then used to determine depth of field or to find the exposure correction factor, see data section.

With some camera equipment it is a simple matter to obtain magnification by reading it from a scale after the subject has been focused and composed. Conversely, the required magnification can be preset using the same scale and then the whole camera moved until a sharp image is obtained. This latter technique can be very useful at times.

In the absence of such scales, simple measurement techniques may be used, where a suitable dimension of the subject is related to its

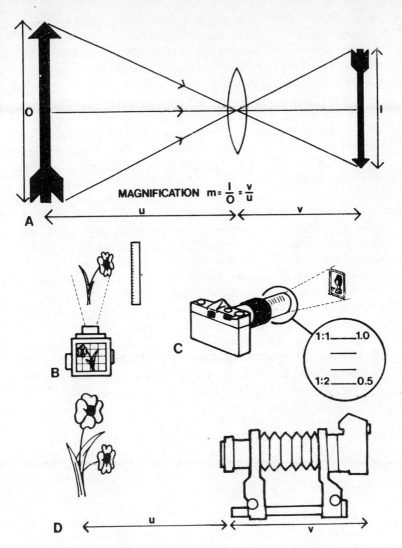

MAGNIFICATION $m = \dfrac{I}{O} = \dfrac{v}{u}$

Magnification and its determination. A. The lens forms an inverted image I of the subject O. B. Magnification found from measurement of both the subject and its image on the focusing screen. C. A macro lens may have a scale of magnifications engraved on the focusing mount. D. Magnification may be determined from measurement of subject distance u and bellows extension v.

corresponding dimension on the image. The formula given previously, m = I/O, is then used. A cross line or checker pattern focusing screen with squares of known size is a great help. With some subjects this technique may not be possible as they may be · too delicate or easily frightened by a ruler.

Sometimes measurement of lens extension from the camera and knowledge of the lens to subject distance can also be used to determine magnification. For magnification can also be defined as the ratio of lens to film distance (v) to the lens to subject distance (u), so that m = v/u. This relationship is demonstrated by the simple geometry of the ray diagram on page 19, which shows image formation by a simple lens.

Unfortunately, most photographic lenses are thick lenses and are often of telephoto or retrofocus construction, so that these measurements cannot be taken from the mechanical centre of the lens but must be taken from other points, termed the front and rear nodal points. The positions of these nodal points are not usually known for any particular lens. Measurements taken to the centre of the lens as a substitute are too inaccurate for magnification calculations in close-up work.

There is often some confusion as to the nearest subject distance that can be used with a particular piece of equipment. Sometimes the nearest distance quoted by the manufacturer is measured from the front element of the lens and sometimes it is measured from the film plane. The first figure is more useful in practice as it gives the clearance between lens and subject, thereby indicating whether it is possible to use a lens hood or a small light source near to the subject.

Types of close-up photography

The approximate limits of the various types of close-up photography, can be defined according to the value of image magnification. There are three widely recognized types or classes with a slight overlap between them.

Close-up photography is used as the general name for this type of photography, it also denotes photography specifically in the magnification range of about 1/20 to 1/1 (0.05 to 1.0). In other

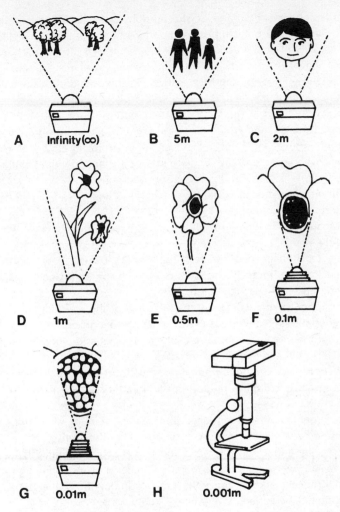

A Infinity (∞) **B** 5m **C** 2m **D** 1m **E** 0.5m **F** 0.1m **G** 0.01m **H** 0.001m

Subject distances with corresponding focus settings and type of photography. A. Infinity setting (more than 100 m)—landscapes. B. 5 m—groups. C. 2 m—portraits. D. 1 m—beginning of close-up region. E. 0.5 m—big close-up, usually with the aid of close-up lenses or extension devices. F. 0.1 m—life-size with a 50 mm lens, beginning of the macrophotography region. G. 0.01 m—macrophotography, special equipment needed. H. 0.001 m—photomicrography. Most cameras can give settings A to D, some A to E, but special accessories or lenses are needed for F and G and a microscope for H.

words covering the range of photography possible using the lens at its usual near focusing distance down to life-size reproduction with easily obtained accessories. A vast range of close-up equipment is available for all types of cameras and problems of exposure calculation, lighting, depth of field and subject matter are usually easily solved.

Macrophotography (also often called photomacrography) has a magnification range which overlaps with close-up photography as defined above and is usually taken to be from about 1.0 to 25. Some workers extend the range to 50 but it is an individual choice. It is important to realize that macrophotography is still a *one-stage magnification* process, that is the camera lens forms an image directly onto the film.

Compared with close-up photography, problems increase very rapidly with increase in magnification. In particular, the lens to subject distance becomes very short and the necessary bellows extension very long. This occurs even with the short focal length macro lenses of special design.

Macrophotography is usually the province of the specialist photographer and is widely used in scientific and technical applications of photography. For optimum results it requires a rare combination of skills, patience and perserverance.

Low-power photomicrography is the third type of close-up photography and has a range from a magnification of about 10 to about 100.

The large magnifications used necessitate a *two-stage optical magnification* system. A primary image magnification of say ×10 is given by a first *objective lens* and this is then magnified by say ×5 by an *eye-piece lens* to give a final overall magnification of ×50. Unlike macrophotography this magnification value is fixed and cannot be varied by means of a bellows extension.

The microscope image is viewed initially by the eye and then may be recorded by a camera attached to the instrument. This use of a camera also contributes to the final value of the magnification.

Once again, photomicrography tends to be a speciality subject with all sorts of problems such as lighting and specimen preparation. However, good quality microscopes are available at moderate cost and most cameras can be adapted for use on such instruments.

Uses for close-up photography

The types, scope and challenges of close-up photography have been discussed but little has been said about the uses to the average amateur photographer. Of course, the professional, commercial, industrial and scientific photographer makes wide use of all the available techniques as essential working tools in production and research.

Amateur photographers will find that close-up photography has an interest all of its own as well as being a useful adjunct to other interests and pastimes. Making full use of the potential of the camera, which may possess close-up facilities, gives a feeling of achievement and satisfaction.

The photographs produced can often be abstract in their form and content although of everyday subjects. The very limited depth of field found with close-up photography is marvellous for removing unwanted subject matter, and so allow concentration on the true essentials of a photograph. Also, the mastery of tricky technique without the need for a large studio, banks of lights or extensive facilities, but needing only a small corner of a room, can be most rewarding.

Another whole field of application is the copying of existing photographs, documents and colour slides. The sizes of these originals places them well within the defined range of close-up photography. Such photographic records can ensure that valuable originals, of monetary or sentimental value, need not ever be irretrievably lost. Also for insurance purposes a record of such items can substantiate and facilitate possible claims.

What do I need to start?

The great attraction of this form of photography is that very little is needed in the way of equipment other than the basic camera. In fact the camera already owned may focus close and possess a reflex viewfinder so that initially nothing extra is needed. But for a start, the simple supplementary close-up lens has many advantages to offer (see page 44).

The other items possessed by most photographers are a tripod and

a small electronic flash gun. These, combined with simple equipment, give a versatile outfit capable of tackling a wide range of general subjects.

It is also easy to set up a small studio for close-up work in a corner of a room or on top of a small table. Indeed for many years the term *table top photography* was used to describe much close-up photography. As will be described in later chapters, many common household items, can be modified and pressed into service as photographic accessories. Items such as metal cooking foil, mirrors, cards, reading lamps, putty, adhesive tape and fishing line will all be found useful at some time.

Possibly the greatest stumbling block in photography is the inspiration required to produce the next photograph. Fortunately, close-up photography uses the most ordinary of objects to reveal detail, pattern and texture enough to interest anyone. As an example, the reader is invited to look around the surroundings where he is reading this book and envisage small areas magnified and revealed in unexpected ways. Or, perhaps, even to wander round with a small pocket magnifier, as previously suggested, and look at detail.

Some of the more common specialities of close-up photography are described on pages 161–177 and offered as suggestions.

Camera Types

Which one is best?

On the market there are many cameras to choose from, and their prices vary from a few pounds to many hundreds of pounds. In general, you get what you pay for, with the more expensive cameras offering a vast range of accessories which form a camera system.

No one camera or lens can hope to cover every situation. A camera excellent for one speciality may be unsuitable for another. For example, a large format camera with close focusing is of little use for action photography, and a special macro lens having a small maximum aperture is of limited application in low light level photography.

The best camera with which to begin close-up photography is your existing camera. Familiarity with your present equipment is a great help in exploring new techniques. Your camera may possess a standard lens capable of being focused down to about 0.5 metre (18 inches). How many pictures have you taken at this distance? Even the simplest camera, with the addition of an inexpensive close-up lens, can greatly extend the subject choice. A developing interest in close-up photography may then lead you to exchange your camera for a more versatile camera system.

But do remember to keep equipment to a minimum, especially with a view to transporting it and getting the camera into action rapidly. The owner of a simple rangefinder camera with a parallax corrected close-up lens may be ready for action long before the owner of a reflex camera has dismantled his camera to attach extension tubes or bellows.

Learn to master the close-up capabilities of your camera. If you find that constant consultation of tables is irksome, copy out the most useful data on a card and attach it to the camera body or case.

Many cameras already have a convenient slot to hold a film boxtop and this serves ideally.

Do not despair if your equipment is not of the best or latest design. When a close-up lens is in use and the camera lens closed down to about *f*16, there is surprisingly little difference in the results from lenses of very different costs.

Cameras can be classified in many different ways, such as by film format, depending on the particular application in mind. A brief description of the major design types with a review of their close-up capabilities may help you realize the potential of your camera or aid you to select a new one.

Film formats

The film format of a camera is the dimensions of the picture provided on the film. It should be noted that nominal format sizes are usually quoted and that the dimensions of the film gate aperture may vary from these values.

There are quite a number of formats in use and they are related to the widths of the various roll films used. For example, formats of 26×26 mm (instamatic type), 24×36 mm (full-frame) and 24×18 mm (half-frame) are all derived from the popular film width of 35 mm.

One consideration when deciding on a particular film format may be the number of exposures possible per load and the possibility of buying film in bulk to reduce cost. This can be very important in natural history photography where a high failure rate can often be expected due to the vagaries of the subject.

A very important consideration when selecting the format size is the dimension of the subject you can photograph at say, life-size. A 24×36 mm format camera could photograph most postage stamps at this magnification but not a small ornament. A larger format, perhaps 6×6 cm or larger, may be needed for this type of subject.

Conversely, for the photography of small subjects, such as insects, it is wasteful to use a large film format with only a small area actually of interest. A small format is much more economical, and generally easier to use.

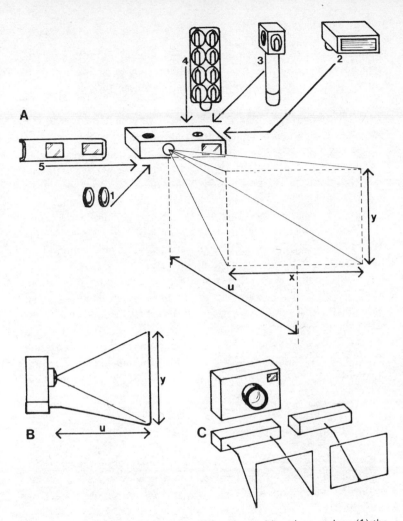

Close-ups with simple cameras. A. When fitted with a close-up lens (1) the field of view of the camera is a rectangle of dimensions x and y mm, at a distance u from the lens. This subject area may be illuminated using an electronic flashgun (2), a flash cube (3) on an extender or by a flashbulb array (4). A useful close-up attachment (5) incorporates a close-up lens plus a grey filter to prevent over-exposure and also a viewfinder prism to correct the view seen. B. Field frames, shown here in side view, may be constructed from wire. Two alternative designs are shown in C for attachment to the base of the camera.

Simple cameras

Examples of simple cameras include many of the 110 and 126 size easy-load and pocket cameras. Other varieties are the lower priced instant print cameras and the venerable box cameras for 120 roll film.

These simple cameras may at first appear very limited for close-up photography, but they can be used and adapted at modest cost. The usual method is to use a close-up lens, see page 27. The problems are then to define the subject area included in the picture and the plane of sharpest focus. The fixed viewfinder is of little value in this mode of use, even though it may have parallax correction marks for subjects at three feet distance. The best solution is to buy or construct a form of *field frame* or *copy legs,* see page 27. Such an accessory can be purchased for some cameras or can be made from thick malleable wire.

The best illumination to use is flash, as the lens aperture is small and many simple cameras can not give a time exposure (B setting). At such close distances, the light output of a flashcube is embarassingly large, resulting in over-exposure. So a suitable diffuser is needed to reduce the light on the subject and also give the bonus of more even illumination. Suitable diffusers are included in the special kits for close-up photography available for some of these cameras.

Rangefinder camera with a fixed lens

The specification of this camera type can vary enormously, with the more expensive having lenses of f1.4 maximum aperture, and a coupled rangefinder focusing to distances of about one metre (three feet).

The bright-line viewfinder usually has parallax correction marks along with the rangefinder images, and may display other data such as shutter speeds and exposure. A limited range of shutter speeds may only be provided and a built-in metering system may be cross-coupled to aperture and shutter or provide full exposure automation. A flas-only manual mode is often available which can be used for flashbulbs or electronic flash. Cameras of such

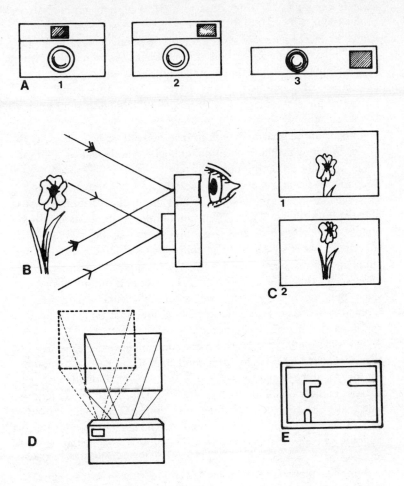

Unless viewing is through the camera lens there will be parallax errors due to the difference in viewpoint between the camera lens and viewfinder. A. 1, 2, 3 are typical viewfinder positions in cameras. B. Parallax error due to vertical displacement of the viewfinder as in A1. C. 1 shows image as seen in viewfinder, and 2 the subject as recorded on film. D. Combination of both horizontal and vertical parallax error for a viewfinder of type A2. E. Parallax correction marks in a typical bright-line viewfinder for a subject distance of approximately one metre.

Note: similar problems occur with measurement areas of exposure meters in cameras *except* those of through-the-lens type.

specifications can be of modest or high price, and use film sizes such as 120, 126, 110 and 35 mm.

While such cameras are excellent for general photography, for close-up work their limitations and problems are much the same as for simple cameras. Once again the close-up supplementary lens is the only solution. There is however a little more scope for use of the close-up lens with rangefinder cameras than with a simple camera.

The first of three possibilities is to use the field frame or copy legs device which is available with suitable close-up lenses as a kit, or it can be made up by the user.

Secondly, a special accessory rangefinder and viewfinder combination with special close-up lenses may be used in the accessory shoe of the camera. The camera rangefinder is inoperative in this instance. Depending on the close-up lens in use, the camera lens focusing scale is set by hand according to the value given by the supplementary rangefinder. This is a slow process, unsuitable for moving subjects unless the camera is preset and the picture taken when the rangefinder images fuse as one. Viewfinder parallax is a problem due to its distance from the lens but it may tilt for compensation as the rangefinder is operated.

A third possibility is by far the most convenient and makes use of the camera rangefinder for a second role in the close-up region. By means of a special glass wedge or prism positioned over the camera rangefinder and viewfinder windows or attached to the side of the close-up lens, the viewfinder images are deviated to the field of view given by the close-up lens. The camera lens may also be focused using the rangefinder due to the compensating action of the supplementary prism. Such devices are small, easily carried and simply attached to the camera. In conjunction with the exposure automation available in these cameras, they represent a very useful and speedy system for close-ups down to about 0.5 metre (20 inches) or so.

Rangefinder camera with interchangeable lens

These cameras have a multi-frame viewfinder or an accessory finder and the lenses available have a minimum focusing distance

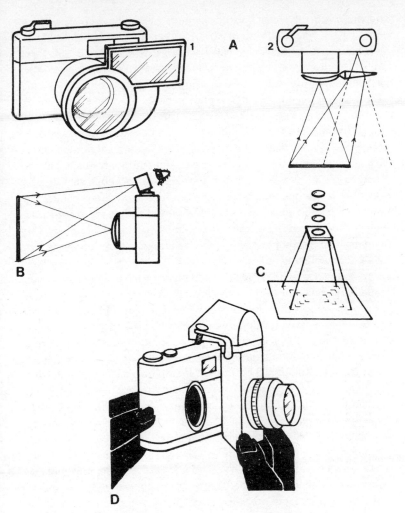

Close-ups with rangefinder cameras. Non-interchangeable lens cameras can use: A. Close-up lens with prismatic correction device for the viewfinder; the principle of operation is shown in A2. B. Supplementary lenses and tilting viewfinder in the accessory shoe. C. Copy leg system of adjustable height for use with close-up lenses. Interchangeable lens cameras can use: D. Conversion units that change the camera into a single lens reflex camera; for example the Leitz VISOFLEX. Copying guages with extension rings are also available to give set reproduction ratios. These are focused by means of a ground-glass screen magnifier which replaces the camera body.

dependent on the design and accuracy of the rangefinder. There are only a few cameras of this type at present on sale. They consist of the various Leica cameras and their foreign cousins, and some large format technical cameras such as the Linhof and Horseman.

Their problems for close-up photography are similar to those previously mentioned camera types. The complex viewfinder and rangefinder systems with automatic parallax correction are only operative to one metre (three feet) or so with the standard lens. Thereafter the usual methods may be used, although the facility for removing the camera lens is of great assistance. For example, the field frame or copy legs device can be used, but instead of having a set of close-up lenses in front of the camera lens, a set of extension tubes may be used between the camera lens and body. By this means, it is possible to obtain high quality reproduction at life size with accurate subject framing.

The camera rangefinder may also be used over a limited close-up range by employing an accessory optical device over the appropriate windows in the camera body. The close focusing 50 mm $f2$ Summicron lens for the Leica uses such an attachment.

Large format cameras have a choice of rangefinder or ground glass screen focusing and the latter has to be used when focusing closer than the minimum distance of the rangefinder. The smaller 35 mm cameras in particular the Leica, can also revert to ground glass screen focusing by converting the camera into a single lens reflex type. A Visoflex or similar reflex housing is used, which can be combined with a wide range of accessories.

This convenience of choice of rangefinder or reflex camera is not the complete answer, as there is no possibility of using normal or wide-angle lenses for distant subjects with the reflex housing. Also there is virtually no automation of camera functions such as exposure measurement, iris operation or instant mirror return. Nevertheless, the system is capable of giving excellent results.

Twin lens reflex camera

The usual format is 60 × 60 mm but some 40 × 40 mm cameras were made. The basic design consists of a pair of lenses of matched

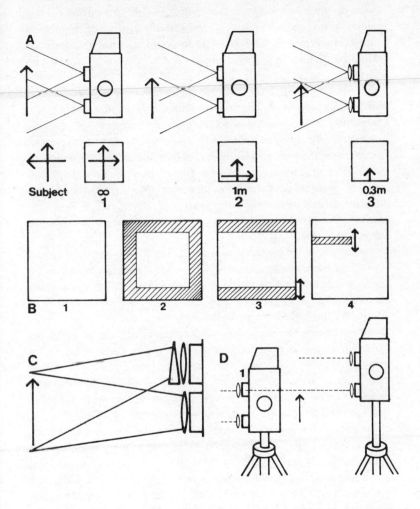

The twin lens reflex camera. A. Viewfinder image as seen: 1. At infinity focus; 2. One metre focus; 3. 0.3 metre focus using a No. 3 close-up lens. B. The viewfinder can be used for parallax error compensation: 1. Area of image on film; 2. Masked down image; 3. Moving frame mask; 4. Moving pointer. C. Special prism over the viewing lens in front of the close-up lens can compensate for parallax. D. Centre column tripod or the Paramender device (not shown) can be used to raise camera as required.

focal length which move together on a common lens panel operated by the focusing control. The upper lens, of poorer optical quality, forms an image for viewing and focusing on a ground glass screen via a 45° mirror. The lower lens, which is used for taking the picture, is of good quality and is fitted with a leaf type shutter.

This arrangement is excellent for distances down to about one metre, the usual closest focusing distance of such cameras (the Mamiyaflex being a notable exception). For subjects closer than one metre the major problem is of viewfinder parallax, because the vertical separation of the two lenses is then a significant fraction of the subject distance. This results in the topmost portion of the subject, as seen in the viewfinder, not being included in the picture area due to the different viewpoints of the two lenses. The parallax error is only vertical, but obviously becomes greater as the subject gets closer.

The error may be corrected down to about one metre by having the viewfinder frame mask smaller than the film format or by having a coupled moving mask as in the Rolleiflex cameras. The Mamiyaflex camera uses a coupled moving pointer below the viewfinder screen to indicate the top of the subject area.

Close-up photography usually means attaching pairs of close-up lenses—the sole exception is the Mamiyaflex once more. This camera, apart from having interchangeable lens pairs, also has a long built-in bellows extension. This allows large image sizes directly without supplementary lenses, which can approach life size with the short focal length lenses. In such instances the top of the subject area is approximately one third of the distance from the bottom of the viewfinder screen. Corrective measures are obviously needed.

A simple corrective action, when a TLR camera is on a tripod and the subject is static, is to raise the camera after focusing and composing so that the taking lens then occupies the position vacated by the viewing lens. The vertical distance between lenses is about 75 mm, and may be achieved by raising the tripod or preferably by using a device such as a Paramender which automatically gives the correct displacement.

Another device, typified by the Rolleipar close-up lens attachment,

is to fit a thin prism over the close-up lens for the viewing lens, so that the field of view is deviated downwards to show the subject area. This is an effective and convenient device but close-up composition is affected as the viewpoint is different to that of the taking lens.

Yet another method is to convert the camera for focusing and viewing directly through the taking lens by means of an accessory back for taking sheet film. A ground glass screen is first inserted for focusing and then replaced by a special darkslide to expose a single sheet of film. This arrangement is obviously restricted to static subject matter.

The lenses available for TLR cameras are usually designed and corrected for distant subjects and may not give excellent results when used for close-up photography. This is especially true when strong close-up lenses are used combined with wide apertures.

This type of camera however, is most versatile and accessories such as pentaprism with built-in exposure metering greatly increase their convenience in use. Flash synchronization with the leaf type shutter is very simple.

A wide range of close-up work can be tackled with just a Mamiya-flex camera due to the convenience of its long 'built-in' bellows extension and its scales giving exposure correction factors for the lens in use. Alternatively, a Rolleiflex camera with parallax corrected close-up lenses of two element construction is a handy tool for large format colour transparencies. One minor criticism of such TLR cameras is that depth of field cannot be judged as the viewing lens has a fixed maximum aperture.

Single lens reflex camera

This universally popular type of camera uses the camera lens to form the viewfinder image by means of a reflex mirror at 45 degrees to the optical axis. This mirror springs out of the way just prior to exposure and may return immediately afterwards or when the film is wound on for the next exposure. The viewfinder image is viewed on a ground glass screen or similar arrangement. A specially shaped glass prism, called a pentaprism, enables the laterally reversed screen image to be viewed correctly orientated comfortably at eye

level. Most camera and lens combinations keep the iris diaphragm in the lens fully open for viewing but close it down to a pre-selected value during the exposure.

The three factors of instant return mirror, pentaprism and automatic iris have made the SLR camera ideal for many photographic subjects, especially all forms of close-up photography. All errors due to viewfinder parallax vanish and the very small subject areas common in close-up work are accurately framed and composed.

In addition, focusing on the subject is precise, for if the subject is sharp on the focusing screen, it will also be sharp on the film plane. Consequently, all sorts of lenses, close-up devices and home-made gadgets can be used with such cameras.

Another useful feature is that subject depth of field can be estimated on the viewfinder screen, although at small working apertures and at long bellows extensions the image can be very dim indeed.

One of the assets of the SLR camera is that it is usually linked to a vast range of lenses and accessories which form a *camera system*. This, of course, includes accessories for close-up photography, macrophotography and photomicroscopy. Items ranging from a simple close-up lens to a photomicrography stand can be purchased, making close-up photography that bit easier.

One useful group of accessories are those for the viewfinder. A choice of waist-level or eye-level viewing is possible and some special magnifying viewfinders may be available. Eyepiece correction lenses and eye-cups assist viewing and the screen itself may be interchangeable.

Instead of the minimum distance of one metre common on other cameras, the standard lens on an SLR usually focuses down to 0.5 metres (20 inches) or less. Alternative interchangeable lenses are also provided with focusing ranges to provide quite useful image sizes. The special macro lens with its greatly extended focusing range down to life size is only available for SLR cameras. Yet another very useful feature of most SLR cameras is an internal exposure metering system, usually based on light measurements from the viewfinder screen. This system is either incorporated in the camera body or available as an alternative special pentaprism. The exposures indicated are based on measurements of light that has passed through the lens, which is most convenient for close-up

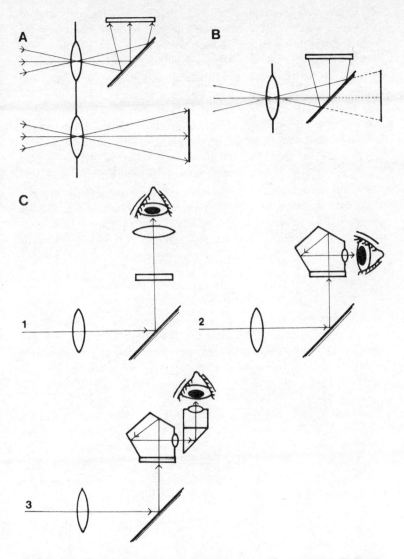

Reflex cameras. A. Principle of the twin lens reflex camera (TLR). B. Principle of the single lens reflex camera (SLR). C. The SLR viewfinder offers a choice of viewing: 1. Waist level; 2. Eye level using a pentaprism; 3. Right-angle viewing using a special attachment for non-removable pentaprisms.

work when extension tubes or bellows are in use. Also, full account is taken of any optical accessories attached to the camera body or lens, see section on exposure techniques.

Various forms of metering are available, including fully automatic types, but perhaps the most useful is the so-called *aperture preferred* method, where the working aperture is set by the user and the shutter speed necessary is then indicated by the meter. Any optical arrangement can then be easily used with through-the-lens metering, and can save a great deal of calculation and puzzling out of exposure. Other systems such as *shutter speed preferred* are not so convenient for close-up work.

Other features of the SLR camera which are available include motorized wind-on devices and interchangeable backs to permit choice of film to suit subject. While no camera offers all possible features, some come close and SLR cameras are available in every film format from those using 110 cartridges to 4 × 5 sheet film.

Cameras for self-developing film

A variety of cameras are available designed to take film packs of self-developing film manufactured by the Polaroid Corporation and the Kodak Organization. These two varieties of instant-print materials are not mutually interchangeable or usable in cameras not specifically designed for them. Film packs are available to produce either monochrome or colour prints.

The cameras range in design from the basic to the sophisticated. The simplest having fixed focus and shutter speed with a modest aperture range to control print density. Others have coupled rangefinders, full through-the-lens metering and electronic shutters. The Polaroid SX-70 camera is a unique type of SLR camera with automatic exposure and focusing to ten inches, or to life-size with a simple close-up lens.

Other specialised camera designs are available with field frames, extension pieces and ringflash for close-up work, usually of a scientific nature.

Some conventional SLR designs in larger formats as well as most technical cameras can be fitted with a special back to take self-developing film. The great advantage is that a result can be seen

very soon after exposure, and if not correct can then be rectified while the subject is still before the camera. This is especially useful where exposure determination, lighting set-up and depth of field can all be difficult to arrange or estimate and only a photograph can give final proof of the correct conditions.

Technical cameras

Although, largely confined to professional users, technical cameras are used for close-up photography by some amateur photographers because of their enormous versatility.

Technical cameras exist for formats from 6 × 7 cm to 8 × 10 inches and can be divided into two major designs. The first is the baseboard type such as the Linhof Technika, Horseman and MPP. These can all be handled and focused using an integral coupled rangefinder and multi-frame viewfinder. The lenses are interchangeable on panels as are their special cams for coupling to the rangefinder.

A limited range of camera movements are possible and the triple bellows extension usually provided gives a ×2 magnification with the standard lens and up to ×20 with special macro lenses. Apart from the optional use of the focusing screen this type of camera has the same problem for close-up work as other rangefinder cameras.

The other design for technical cameras is the monorail type, which is basically an optical bench. A long sturdy rail carries the front and rear standards to which are attached the lenses, bellows, film holders and other accessories. Very long bellows extensions are possible, allowing very large magnifications with suitable lenses. Viewing and focusing is on a ground glass screen only.

The various camera movements provided on the front and rear standards are used to control focus, depth of field and image shape. These functions are most useful for close-up work when depth of field is usually very limited. A useful accessory available for some cameras is a special rear panel to take a conventional SLR camera body of smaller format so that the monorail camera then acts as a giant form of extension bellows of great versatility.

Monorail cameras, because of their construction, can only be used on a sturdy support such as a firm tripod.

Basic Techniques and Equipment

Unaided focusing range

By definition, close-up photography begins when image magnification exceeds about 1/20. This typically is given by a standard 50 mm lens for 35 mm photography when focused at approximately one metre. So focusing at less than this value brings you into the close-up range.

On many simple cameras the lens is of fixed focus, that is, it has no focusing movement. Instead it is focused permanently on its *hyperfocal distance* which gives maximum depth of field at the working aperture. The depth of field extends from infinity to half the value of the hyperfocal distance from the camera. Typically this near distance is four to six feet. Obviously, close-ups are not possible without optical aids; some of these devices are illustrated on page 27.

Modern lenses, especially those for SLR cameras, have near focusing distances of typically 0.5 m (18 inches). Long-focus lenses do not focus so close but at their nearest distance give image sizes approximately the same as the unaided standard lens at its near distance. Wide-angle lenses have even greater ranges and typically focus down to 30 cm (one foot) or less—however, image magnification is not very large. A 24 mm lens focused on a subject 30 cm distant gives a magnification of approximately 0.1, see data section.

A recent innovation is *internal focusing* of a lens, where the internal elements are moved slightly to give a good focusing range without the need for a complex mechanical focusing mount. Also, when used in conjunction with through-the-lens metering, the close-focusing is easy to operate, since the metering system automatically allows for any necessary exposure corrections. This type of lens design is therefore ideal for close-ups.

Where are distances measured from?

As mentioned previously, subject distances are sometimes measured to the front element of the lens. This has some value when you want to know the clearance available for lens hoods and lights, but it is not easy to measure and to repeat the set-up if required.

A better measure, although not so impressive for performance figures, is to give the distance of the subject measured from the film plane. The position of the film plane is usually clearly marked on top of the camera body. Such distances may be quoted as giving a particular magnification with a given lens, the camera body can then be positioned accordingly and the lens used to focus the image sharply. This method is much easier than setting the distance between the subject and the front lens surface and adjusting the camera body to focus.

Built-in bellows

Some cameras, almost all in the larger format category, have built-in bellows for focusing the lens. The light weight, low cost and compressibility of camera bellows means that considerable extensions are possible allowing focusing for very close subjects, whilst still allowing the lens to focus on infinity.

Cameras with built-in bellows include the Linhof technical camera, which has enough extension to give a ×2 magnification with the standard lens; the Mamiyaflex TLR, and the Rollei 66 SLR.

Close-focusing wide-angle lenses

The extension that a lens requires to focus on close subjects is related to its focal length. A wide-angle lens which has a short focal length needs only a modest extension to provide very close-focusing. Focusing down to a few centimetres is not uncommon with a wide-angle lens. The close viewpoint, together with the wide-angle of view, can combine to give a very unusual perspective of the subject.

For some critical applications, when the lens definition must be

of a high standard, the performance of such a lens at close distances can be mediocre. This fault can be greatly improved by the use of a *floating element*.

Floating elements

A lens is usually designed for an excellent performance when imaging distant subjects. At close distances, some designs are prone to give a reduced standard of performance, particularly those of large maximum aperture and wide angle of view.

Experience gained from the design of zoom lenses, in which groups of elements move to alter focal length, has led to the introduction of a movable or floating element in leading designs of wide-angle lenses. This element is coupled to the focusing movement and moves to provide a marked lens improvement at close distances, especially at large apertures. Floating elements are also used in standard and long focus lenses of large aperture.

Close-focusing telephoto lenses

An apparent contradiction of terms is when a close-up is required from a distance. Close-up photographs are usually associated with the camera being near to the subject. But many subjects may be timid, unapproachable or fragile. So when a large image is required, the use of a long focus lens permits both a distant viewpoint and a reasonable magnification.

A suitable focusing mount can give a continuous focusing range from infinity down to say a magnification of one quarter life size. For example, a 300 mm lens on a 35 mm SLR camera, which could be focused to 1.5 metres (five feet) would give such a magnification.

Lenses of very long focal length often use mirror or reflecting optics so that a 'folded' design is possible. The great advantage of such mirror lenses is that only a very small axial movement of the primary or secondary mirror is needed to give a very long focusing range. For example, a 1,000 mm mirror lens can easily be made to focus down to two metres (6.5 feet) when life size reproduction is given! However, the closest focusing is usually greater than this distance.

There are disadvantages in such techniques of course. Depth of field is extremely small, camera shake is a great problem and image quality may deteriorate at close distances.

What happens when I focus close?

The action of focusing takes the lens bodily away from the film plane, increasing the lens to film distance. Harking back to the days of mahogany and brass cameras this is often called *bellows extension.* At first only a small extension is needed to focus down to middle distances such as seven metres (23 feet). A greater lens to film distance is needed to focus to one metre (3.3 feet) and this extension progressively increases as subject distance decreases. In fact when life size is reached, the extension necessary is twice the focal length of the lens. This is often called *double extension* and was a common feature on earlier cameras. Nowadays it is a special feature on a few lenses and cameras only.

As the subject in focus approaches closer to the lens the depth of field (see page 74) becomes progressively smaller and smaller until there is virtually only a plane of sharp focus. Unlike general photography, depth of field in the close-up region is independent of the focal length of the lens. Depth of field scales on the lens mount are of little use below about one metre, so tables have to be consulted, see data section.

Also, the angle of view of the lens progressively decreases to half its normal value at life size reproduction. This causes difficulties with optical viewfinders but reflex focusing always gives the correct field of view.

Finally, with increase in image magnification, the *relative aperture* of the lens, a calibration which is based on infinity focus, progressively alters. Consequently the calibrated values on the aperture ring are incorrect. Instead, *effective aperture* values must be calculated, based upon the lens extension. For details see the section on exposure techniques.

Some lenses such as those of very large aperture, are not usually a good choice for close-up work as they can give disappointing resolution. A lens aberration called *spherical aberration* is often the cause of this.

Another lens aberration that is often found at large magnifications is *curvature of field.* The lens gives a flat image on the film plane for distant subjects but for very close subjects the image is curved or saucer shaped. This means that not all the subject can be in focus on the film plane. It is easily detected since the centre of the image is sharp and the edges are out of focus, and vice versa. Often this effect is unnoticed but makes close-up copying of flat subjects impossible.

It is well known that a lens improves as it is stopped down from full aperture, with the optimum being about three stops down from maximum. This is also true for close-up photography, and small apertures tend to give better performance. But if the lens is stopped right down at large magnifications, the effective aperture may then be very small and an optical phenomenon called *diffraction* causes a marked deterioration in the image. Once again, simple tests can establish the aperture setting that gives a reasonable compromise between depth of field and resolution.

The above remarks must not be taken as a deterrent to close-up photography. But, as always, a little knowledge of the usual sources of image degradation will enable you to obtain the best results from your equipment.

Close-up (supplementary) lenses

Understandably the most widely used of all the close-up devices in photography is the *close-up lens* or *supplementary lens.* Not the least of its advantages is its low cost.

The close-up lens is a simple positive lens, and therefore, has a slight magnifying power when used visually. (A negative lens diminishes objects in its field of view.) It is attached to the front rim of the camera lens. The combination of these two lenses, with the camera lens set at infinity, produces sharp images of subjects positioned at the focal length of the supplementary lens. So, if the camera lens is focused for infinity and a supplementary lens of focal length 50 cm is used, then a subject at 50 cm from the lens will be in focus. If the focusing scale on the camera lens is used then a narrow focusing range is obtained, see data section.

Close-up lenses are available in several different focal lengths, the

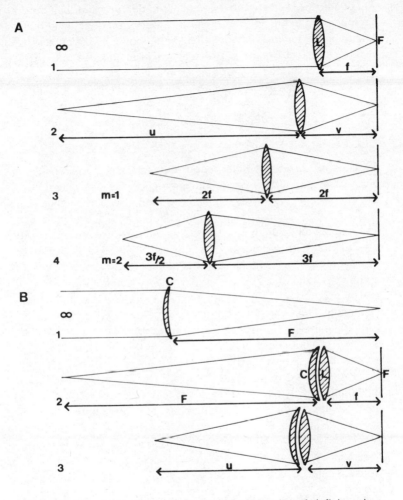

A. Close-up focusing when the camera lens L focused on: 1. Infinity, where *f* is the focal length of the lens; 2. Distance u, where v is the distance of the lens from the film, note that v is greater than *f*; 3. Two focal lengths distance, note that the lens to film distance is also two focal lengths and life-size reproduction is given. 4. Three focal lengths extension, magnification is twice life-size. B. 1. Close-up lens C has a focal length F; 2. When used with the camera lens focused on infinity, subjects at distance F are in focus; 3. When the camera lens is focused at a closer distance.

shorter the focal length the closer you can get to your subject. For general convenience, they are classified in terms of their *power* or strength, the greater the power the shorter the focal length and the greater their magnifying effect. The power is calculated by dividing the focal length (*f*) of the lens in millimetres into 1,000. This result is quoted in *dioptres,* a unit also used by opticians to measure the power of spectacles.

$$Power = \frac{1,000}{f} \text{ dioptres}$$

So a close-up lens of focal length 500 mm has a power of +2 dioptres, or +2D. The plus sign indicates a positive lens, and powers of +1, +2 and +3 or greater are commonly available. Close-up lenses can be combined for greater effect, with the best results being obtained when the strongest lens is closest to the camera. So a set of three lenses of powers +1, +2 and +4 dioptres gives a range of +1 to +7. The resultant power is conveniently given by simply adding their dioptric values. For example, a combination of a +1 and a +2 lens gives a combined power of +3 dioptres. Supplementary lenses are often simply designated 1, 2, 3 and so on by some manufacturers. These may correspond to the power in dioptres, but not necessarily so.

As previously mentioned, it is often a great convenience to take close-ups from a distance using a long-focus lens, but unfortunately most of these lenses do not focus very close. The obvious solution is to use a close-up lens which adds very little in weight and cost. However, the usual powers of +1 dioptre and greater are not much use as the consequent jump in focusing from five metres to one metre leaves a great gap in the focusing range.

Consequently, a range of *fractional dioptre* close-up lenses are available solely for use with long-focus lenses. Typically, values of $+\frac{1}{2}$ and $+\frac{1}{4}$ dioptre give near focusing at two metres and four metres respectively, see data section. These distances are available on standard and wide-angle lenses using the normal focusing mount of course.

Supplementary lenses are available in a variety of qualities and forms. It has been found that the best shape for a simple single

element close-up lens is a meniscus shape, that is with both lens curvatures in the same direction. The lens is fitted to the camera with the convex curved surface towards the subject.

The drawback to their use is that the camera lens is best stopped down to medium or small apertures, say $f8$ and preferably $f11$ or $f16$, so as to be sure of reasonable results and usable depth of field. Using the lens at full aperture gives unacceptably soft results due to aberrations. The delicate balance of corrections in the camera lens is upset by the presence of the close-up lens.

Better results are obtained with a supplementary lens that is a cemented doublet. This reduces chromatic aberration, which appears as coloured fringes around subjects when colour film is used, and reduced definition when black and white photographs are taken. Examples of the doublet type are the Proxars, Rolleinars and Elpro lenses. In the case of the latter, they are designed for specific Leitz lenses and give excellent results even at large apertures. However, such close-up lenses are much more expensive.

As in the case of camera lenses, anti-reflection coatings are of great advantage in reducing the possibility of lens flare. Single layer coating is common, even on cheap types and multi-layer coatings are used on the more expensive close-up lenses.

A great advantage in using close-up lenses is that they have no effect on the marked aperture values of the lens, so that a set value of say $f11$ on the camera lens can be used in exposure calculation with any close-up lens. This is not true when extension tubes and bellows are used, see section on exposure techniques.

The prime advantages of the close-up lens are that it is cheap, small and easily portable; indeed a set of three can easily be slipped into the pocket. They can be swiftly attached to the camera and brought into action long before extension tubes or bellows can be unpacked and put on the camera.

If only one is carried for convenience, then a +2 dioptre is perhaps the best choice. The +2 dioptre lens gives a close-up range from 50 cm (20 inches) to less than 30 cm (12 inches).

Another advantage is that the close-up lens can be used with any camera, and for most non-interchangeable lens varieties it is the only way of achieving close-up photographs. Most cameras of this type have viewfinders usable to one metre or so, with the field

covered by the lens outlined by a bright-line frame. This is incorrect for closer distances as a smaller field is covered. The frame is also not accurate. The other source of error is *parallax,* which is the difference in viewpoints between the camera lens and an off-set viewfinder. So, while methods exist to give the field of view accurately, the composition of the subject may be unsatisfactory due to the different viewpoint. A variety of solutions are possible, a few of which are worth mentioning because of their wide applications.

The twin lens reflex camera (TLR) uses a pair of close-up lenses with one over each lens. Although there is no focusing problem for close-up pictures, there is a parallax error as the viewing lens is vertically above the taking lens. One solution is to have a small prism in front of the viewfinder supplementary lens so that the correct field of view is seen. However, the viewpoint is still different. If the camera is on a tripod, a parallax correction device such as a Paramender, or the centre column of the tripod, can be used to raise the camera taking lens into the position occupied by the viewing lens. Obviously, this only works for static subjects.

Rangefinder cameras, which have framing and parallax problems due to their offset viewfinders, also sometimes use prism devices in front of the rangefinder and viewfinder windows. The focusing range obtained is comparable to that of an SLR with a supplementary lens.

Yet another system is to use a special accessory rangefinder which fits into the accessory shoe. This rangefinder is for near distances only and is calibrated for a set of close-up lenses. A viewfinder is also incorporated and the instrument tilts when focusing, to give a form of parallax correction. This system works especially well on simple cameras.

The twin problems of the exact plane of focus and the exact area of the subject covered are often most easily and cheaply solved by use of a field frame or copy legs.

The field frame can be made from wire coat hangers or similar objects. With the camera back open and without film, the shutter is locked open using the B setting and a piece of ground glass inserted in the focal plane. With the close-up lens fitted the subject area in focus can be determined by inspection. The wire can be bent

around this area and led back to fix beneath the camera. The frame can now be used with the camera loaded to accurately frame and focus the subject. Usually the field frame is made larger than the area covered so as not to be included in the picture.

A more sophisticated device is the copy legs arrangement. Four telescopic legs fixed in a collar around the lens, splay out so that their tips indicate the corners of the field of view and of such length that they are at the plane of focus. Such copy legs can also be used with extension tubes. Telescopic design with click stops allows for use with two or three different close-up lenses.

Zoom close-up lenses

Close-up lenses are usually only available with a fixed power, and values up to +10 dioptre. However, it is sometimes inconvenient to have to combine two lenses of a set to get the exact framing required. Close-up lenses with variable power are available, typically with a continuously variable range from +1 to +8 dioptres. Termed zoom close-up lenses they can give a continuous focusing range from one metre (3.3 feet) to about 10 cm (4 inches) from the lens.

This attachment, similar to a conventional supplementary lens, screws into the camera lens but is about the size of a camera lens. A rotating focusing ring is the only control. The variable power is achieved by altering the separation between the two lens elements of the attachment.

The results given are quite reasonable, especially if the lens is well stopped down. Colour correction can be poor and colour fringes may be obtained with colour film. The large front element is usually a different diameter to that of the camera lens so that existing filters and lenshood may not fit.

The cost of a zoom or variable close-up lens is moderate, comparable to a high quality supplementary lens. They can only be used with an SLR camera with its parallax free viewfinder system.

Macro-couplers

The owner of an SLR camera with two or more interchangeable lenses can, by the purchase of a simple accessory, convert one

into a very highly corrected close-up lens. This accessory is usually called a macro-coupler and is a thin metal ring with male screw threads at each side for screwing into the filter mounts of two lenses. So, the lenses are connected front element to front element. Usually lenses with identical size filter screw mounts are best. The longer focal length of the two lenses, say 85 mm, is mounted on the camera and the shorter focal length, say 50 mm, then acts as the multi-element close-up lens. With both lenses at infinity focus settings, the camera is sharply in focus some 50 mm from the front lens. Results can be excellent and superior to simple close-up lenses.

Extension tubes and rings

As previously stated, to focus close a lens must be considerably extended from the camera body. This extension is not proportional to magnification but becomes increasingly greater as magnification increases. Most lenses in focusing mounts have a limited range of extension, often due to the limitations of mechanical design.

Provided that the camera lens is interchangeable, then a very simple method of increasing the extension of the lens is to insert an extension tube or ring between the camera lens and body. The extension tube is provided with the necessary male and female, lens and camera fittings respectively at either end. These tubes are usually sold in a set of four, each of different length, and are relatively cheap.

The easily manufactured screw thread fittings are used for the in-between extension tubes for bayonet mount cameras. This arrangement keeps costs to a minimum.

A set of extension tubes (three, four or five) is usually arranged so that the combined length will give the correct extension for life-size reproduction when used with a specific standard lens. This can be useful as it is not easy to manipulate some close-up devices to give a precise magnification of one.

The individual tubes in a set may have various pieces of information engraved upon them, including one or more of the following: length of extension in millimetres, exposure increase factor and the magnification given when standard lens is set at infinity focus.

Use of the camera lens focusing mount gives in addition a small range of magnification.

Some extension tubes have a *helical focusing mount* to give variable extension. They are particularly useful, saving time wasted in swopping and combining tubes of fixed length.

The characteristic of extension tubes is that they give discrete steps of magnification, unlike extension bellows which give continuously variable magnification.

As regards focusing and framing, extension tubes are ideally suited for the SLR camera. Also, because of their fixed magnification they are easily used with field frames or a copy pod.

Long-focus and telephoto lenses can also make use of extension tubes to bring their nearest focusing distance much closer. A single ring of correct length used with a 200 mm lens can bring the nearest focused distance from say three metres (ten feet) to 1.5 metres (five feet), thereby allowing very large portrait heads, for example. For very long lenses the necessary extension length can be quite long and very sturdy tubes are needed to give the required rigidity.

Compared to the close-up lens, the extension tube gives better optical quality. The close-up lens upsets the careful optical balance of a lens and inevitably reduces performance. The extension tube in no way interferes with optical design, and only increases the mechanical distance between lens and film. So, lenses can retain their performance and be used at large apertures, provided small depth of field is acceptable.

It is worth inserting a few cautionary remarks about lenses at this point. Many lenses give a very good performance in the close-up range even if designed for distant subjects. Other lenses do not and using extension tubes can be disappointing. Often only practical tests show up such behaviour.

One type of lens prone to poor results in such instances is the retro-focus design of wide-angle lens. This design gives a lens of short focal length but a much longer mechanical distance between the rear element and film plane, so as to allow the use of a reflex mirror. The temptation is to use a short extension tube to give a big close-up due to the resultant short subject distance. Unfortunately, results are usually disappointing.

Some large aperture lenses have similar drawbacks. Often the use of a reversing ring (see below) can improve matters. Also, telephoto lenses of very compact design can also give poor definition with large magnifications.

Unlike supplementary lenses, extension tubes require correction to the calculated exposure. In fact, sufficient extension to give life-size reproduction requires a quadrupling of the calculated exposure, see section on exposure techniques. These correction factors can be supplied in the form of a table. Use of two or more tubes simply means combining the individual correction factors. Through-the-lens metering automatically takes into account any lens extension, and avoids any exposure calculations. Some problems of meter sensitivity can arise with long extensions and stop-down metering at small apertures. In fact, stop-down metering is often necessary with the use of the simpler forms of extension tubes.

When using some SLR cameras and extension tubes, there is a loss of all automatic functions in the lens, as the appropriate connections between lens and camera body are broken by the extension tube. The most important function lost is the automatic iris diaphragm so that the mechanism has to be manually operated. This is obviously inconvenient for focusing, especially when photographing moving subjects. Various devices using manual plungers to keep the lens iris open for focusing or a double cable release arrangement to stop down the lens before exposure, have been produced to overcome this problem. Also, loss of full-aperture metering, which occurs with some extension tubes and cameras, slows up the picture taking process.

In addition, automatic cameras using shutter speed priority systems normally lose their automatic metering with extension tubes, see section on exposure measurement.

Fortunately, at some little extra cost, extension tubes are available which have linkages that couple the camera body and lens functions. Their advantages offset the minor inconvenience of ensuring correct alignment of all connections.

Before purchase, tubes should be carefully inspected to see that their insides are efficiently blacked and that there are no reflecting screws or linkage rods to cause flare.

Extension tubes can be combined with supplementary lenses to give added magnification. Also, the normal use of filters and lens hoods is in no way affected.

Lens reversing rings

The valid criticism of many lenses that performance is not very good when used for big close-ups, can often be removed by the use of a cheap and simple accessory, the lens reversing ring. To use, the camera lens is removed from the camera, and one end of the reversing ring is screwed into the filter thread of the lens. The ring is then attached to the lens mount, and the lens is thereby positioned with its rearmost element towards the subject.

The improvement is most marked when the lens is working at high magnification on a long extension tube or bellows. The reasoning behind this gadget is that camera lenses are usually designed for imaging distant subjects, that is, more than 1,000 focal lengths away. Consequently, lens to subject distance is much greater than lens to film distance. For close-ups this situation changes and there is less difference between them; for life-size magnification these distances are equal. By reversing the lens construction as described, the lens to subject distance can be less than or equal to lens to film distance and the lens is working as designed. This arrangement is very often used for slide duplication at life-size reproduction.

The reversing ring has little length of its own, and can be carried as a very light accessory for occasional close-up work at fixed magnification. Unfortunately, reversing a lens in this way causes loss of automatic iris and meter coupling functions so that through-the-lens metering may only be used in a stop down mode. One or two other accessories assist in using a lens reversed.

Iris actuating ring

When the lens is reversed the iris actuating pin points at the subject and is not easily operated by hand. Some iris mechanisms hold the aperture fully open against spring pressure, others at the set f value when the lens is not inserted in the lens mount.

An iris actuating ring attaches to the lens and a plunger mechanism engages with the iris mechanism. On one design, finger pressure on an external lever opens up the lens to full aperture for focusing and stops down on its removal. Another design uses a double cable release to stop down the iris, which is normally held fully open, just before the shutter is released. Obviously a wide-open lens gives a bright image that is easy to focus.

The side of the device facing the subject may be equipped with suitable fittings to take filters and a lens hood, for these cannot otherwise be used on the reversed lens.

Reversing zoom lenses

Some designs of zoom lenses, notably the ones of smaller size and shorter zoom range, if used with a reversing ring, can give a zoom close-up range. The magnification range may typically be from one-third to more than life-size on operation of the zoom control.

Results can be very acceptable if moderate or small apertures are used. The disadvantages are loss of automatic iris and the need for stop down metering.

The effects described may not work for some zoom lenses, but a test is worthwhile.

Extension bellows

Whereas tubes give only fixed magnification and must be dis-sembled and re-assembled to alter magnification, extension bellows give continuously variable magnification. The actual range being dependent on the focal length of the lens and the length of the bellows.

The extension bellows acts in the same way as a bellows on a plate camera and is attached between the camera and the lens. To increase extension still further, extension tubes can be used between bellows and lens.

The bellows, typically of 150 mm (six inches) full extension, are attached at either end to a panel. One panel is attached to the camera body, the other carries a lens mount. The underside of the panel should have bushes for tripod attachment to give good balance with a heavy lens at full extension.

The panels may be attached to single, double or even triple rails. These guide rails may have rack and pinion focusing with a left or right hand focusing knob and lock. Alternatively, the panel may unlock and slide along the rails.

For rectangular format cameras, there has to be a rotating fitting at the body attachment end to allow the camera to be turned through 90 degrees for horizontal or vertical pictures, without having to turn the whole assembly.

An interchange of the camera and lens mount panels is sometimes possible so that the same bellows can be used with various cameras and lenses. In addition, unusual lenses may be adapted for use, such as enlarger or cine lenses, see page 62.

One or more of the rails may carry some form of scales and index. This may be the magnification at that extension with a particular lens, or it could be a scale of exposure increase factors, see data section. Alternatively, it could be just a simple scale of millimetres as measured from the film plane. Often all three are found.

The minimum extension of a bellows unit is still quite considerable and a camera lens usually cannot be focused on infinity due to this extension. This is no problem if only the close-up range is used, but many photographers prefer a lens on a bellows unit that can focus continuously from infinity to life size in close-up. The use of such an arrangement is delightful and most photography can be tackled with such a system, with the notable exception of work with a wide-angle lens.

Consequently, some lenses may be provided in a *short mount* version, which is just the optics less the focusing mount. The minimum extension then allows focus on infinity and the maximum gives unit magnification. Focal lengths of 65 to 135 mm are available. Other lenses, notably some of those for the Leica, can have the optical section unscrewed from the focusing mount for the same purpose.

When buying bellows it is best to avoid the compact but flimsier designs if heavy lenses are to be used. Unfortunately, sturdy bellows units are bulky and more expensive. Also, with simpler bellows all automatic and metering functions of a lens are lost. Iris actuating rings, double cable releases and so on are needed to automate the system.

More advanced and expensive models have automatic iris operation via connecting rods between camera body and lens. Alternatively, an iris operating mechanism for cable release or manual operation may be built into the lens panel.

Tripod focusing racks

This unit can take the form of a separate, add-on accessory or be integral in the bellows design. In operation it is a separate rack and pinion arrangement so that the bellows plus camera can be bodily moved to and from the subject. Use of this control in no way alters bellows extension. The purpose of the arrangement is to facilitate focusing and setting of given magnifications.

With the bellows alone attached to a tripod, the lens is racked back and forth to focus the subject. This may give an image that is too big or too small in the frame. So the tripod is moved to and from the subject and the image focused until the required picture is obtained. This can be a very tedious operation, especially when a specific magnification is required. The easy way is to adjust the lens position to give the desired magnification (the scales help here), position the bellows in the central part of the focusing rack, align the tripod approximately correctly and then fine focus using the focusing rack. In this way, lens to film distance is not altered, and magnification remains constant.

Extension bellows systems

In common with the philosophy of system cameras which offer a wide range of accessory items, the simple extension bellows has expanded into a whole sub-system of its own, with related accessories and features to increase versatility and the range of applications.

Most bellows are relatively large in size with long extension, typically 150 mm (six inches), suitable for studio use; so camera manufacturers may also offer a smaller simpler version for field use. The system bellows usually has a large cross-sectional area for reduction of flare and freedom from vignetting. A tripod focusing rack is incorporated, which has separate focusing and lock controls.

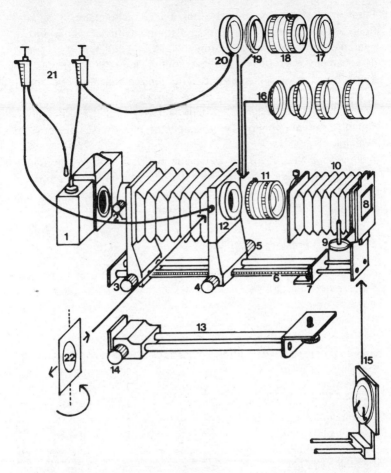

An extension bellows system. 1. Camera body; 2. Release for horizontal or vertical position of camera body; 3. Lock for rear focusing standard; 4. Lock for front focusing standard; 5. Focusing knob; 6. Extension scales on rail; 7. Lock for extension of slide copier attachment; 8. Diffuser for slide being copied; 9. Spool holder for strip of film; 10. Bellows type lens hood; 11. Lens in normal position; 12. Lens mount (interchangeable); 13. Tripod focusing rack; 14. Tripod bush and focusing control; 15. Alternative specimen stage attachment; 16. Extension tubes; 17. Adapter ring for lens hood when lens is reversed; 18. Lens in reverse position; 19. Lens reversing ring; 20. Extension ring to operate auto iris mechanism; 21. Double cable release to operate camera body release and auto iris (two possibilities are shown); 22. Movements on front lens standard.

Front or rear focusing may be possible. Rear focusing is a great boon with a fixed lens to subject distance as it only alters image sharpness and not magnification.

The camera may be rotated without fouling any controls for vertical or horizontal pictures. The lens panel may be interchangeable and some form of iris automation is included. Full aperture metering may be possible as well, and these are often called 'automatic bellows'. A variety of clip-on scales may be available.

A very special case of an extension bellows system is when a camera body of small format is attached to a large format monorail technical camera, permitting enormous extension and access to a full range of camera movements and accessories.

Lens panel movements

A few bellows units, such as those for Nikon and Bronica cameras, allow movement of the front standard carrying the lens panel. Because of space these movements are limited compared to those of a technical camera.

The displacement movements of rising and cross front are very useful for centering the subject in the field of view. When used with the slide copying attachment (see below) it permits selective cropping and enlargment of portions of the original slide. Rising and cross front movements have no effect on image shape or sharpness. The tilt movement is useful when you need to increase depth of field in a particular plane. By tilting the lens panel so that the subject plane, lens panel plane and film plane would coincide, if extended to some point in space; the subject plane is rendered in focus. This is known as Scheimpflug's Law and is widely used with technical cameras. Since much close-up photography is concerned with obtaining sufficient depth of field and a sharp subject, this tilt feature can be very useful.

Slide copying attachment

A slide copying attachment can be fitted in front of some extension bellows. Usually it is a panel with a suitable aperture and mounted

on a rail or rails which slip into the hollow rails of the bellows and are secured in place. The colour slide mount is held firmly in place, usually by magnetic clips. Special holders are available for uncut strips of film. A macro lens is usually the best choice and lens panel movements assist in alignment with the original.

A very useful accessory is a supplementary extending bellows that is attached between the lens and the slide panel so as to exclude unwanted light and surface reflections.

The slide is illuminated through a diffuser positioned behind the slide. Either electronic flash or tungsten lighting can be used.

Bellows lens hood

Since a lens may be used in reverse on a bellows and also because the field covered narrows in close-up as compared with distant scenes, the usual lens hood may be unusable or inadequate.

An accessory lens hood in the form of an extending bellows may be fitted to the front of the lens panel and pulled out as needed to shield the lens. Check the viewfinder to see how much hood extension is possible before vignetting occurs. These lens hoods are extremely efficient.

The open front end of the hood can also be used to hold a simple slide copying attachment or devices such as masks or vignettes.

Specimen stage

Often small subjects can be difficult to hold still and locate accurately. The specimen stage, a term borrowed from microscopy, is an attachment to the front of the extension bellows to give a flat surface, parallel to the film plane on which the subject can be attached, rotated and sharply focused.

The actual stage plate is interchangeable to allow transparent, translucent, opaque or coloured ones to be used, depending on the lighting required, see the section on Lighting.

Macro lenses

Obviously, the best close-up results are obtained using lenses specially designed for close-up work. Such lenses are usually

optimized for best performance at a magnification of 0.1 but are very good up to unit magnification. Thereafter, lens reversal is recommended. These lenses are called 'macro' or 'micro' types, although this description is a misnomer by definition, and sometimes misleading.

These lenses have an extended focusing range by means of a special lens mount with a double helical extension arrangement. The usual range is from infinity to a magnification of 0.5, then by means of a special extension tube supplied, the same focusing mount gives the magnification range 0.5 to 1.0. A few give an extended range from infinity to unit magnification.

Macro lenses are designed for SLR cameras and therefore have an automatic iris and exposure meter coupling. Usually the special extension tube has suitable couplings so automation is retained.

Two focal length ranges are available for 35 mm SLR cameras, one from 40 to 55 mm, the other from 90 to 135 mm. Maximum apertures are from $f4$ to $f2.8$.

Some macro lenses are available in a cheaper short mount version without any focusing arrangement, for use on extension bellows. A click-stop or pre-set iris may be fitted for convenience. The unusual 65 mm Leitz Elmar lens is one example of this type.

Larger format cameras have very little choice of macro lenses, and are in the range of 120 to 135 mm focal length, such as the Zeiss S-Planar lenses.

One lens worth special mention is the Vivitar Series One 90 mm $f2.5$ macro lens which incorporates a floating element and also special field flattener elements in its extension tube. This lens comes close to being an ideal universal lens.

Macro lenses are also very useful for general photography. Their simpler construction makes them light in weight and the use of extension tubes or bellows can be dispensed with for many subjects. The lens can be left permanently on the camera instead of a conventional standard lens.

Their only drawbacks are their modest maximum aperture and their inferior performance with distant subjects compared to normal lenses. Provided that not much low light level photography or landscape work is anticipated, then a macro lens is an excellent choice as a standard lens.

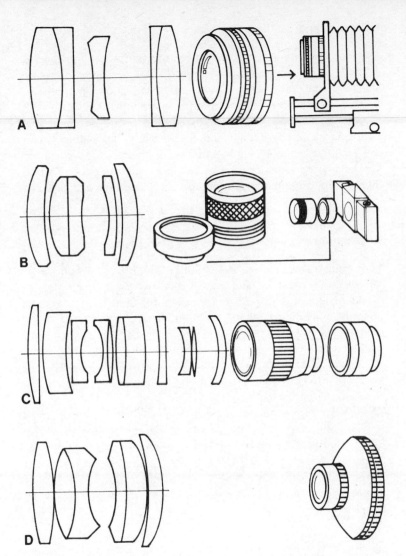

Macro lens designs. A. Short mount lens of long focal length for use on a bellows only. B. Macro lens for use on a camera, focusing to a magnification of 0.5, a special extension tube gives the range from 0.5 to 1.0. C. Longer focal length macro lens of special design using a floating element and additional corrective elements in a special extension tube. D. Special macro lens of 25 mm focal length for the magnification range of 2 to 10 only.

Enlarger lens

The lens for an enlarger is designed for short subject (negative) to lens distances and long image (paper) to lens distances. Consequently, the better quality varieties usually perform extremely well on an extension bellows, even without reversing it.

Enlarger lenses have only a few possible screw thread fittings, such as the Leica 39 mm fitting, and adapters are easily obtained for use with the common lens mounts.

The lenses are not automatic, and have a click-stop aperture ring. In addition, most have no provision for the fitting of filters or a lens hood.

Cine camera lenses

Very high quality lenses of fixed focal length are produced for 16 mm cine cameras, and they make excellent macro lenses. Standard lenses are of 25 mm focal length and large maximum aperture, providing easy focusing and large magnifications with moderate extensions. Reversing such lenses may give greatly improved results. Lenses for 16 mm cine cameras have a standard 'C' screw mount and adapters from this to other fittings are readily available. Cine lenses have no automatic iris, and perhaps only a click-stop arrangement.

There may be some puzzlement as to why a lens which is designed to cover the diminutive 16 mm format may be used with 35 mm formats and larger. The reason is that as the lens to film distance increases, the base of the cone of light emerging from the lens increases. The greater the extension the larger the format that the lens will cover. At sufficient extension, even 4 × 5 inch film could be used.

Zoom lenses with macro focusing

The zoom lens is one whose focal length can be varied while retaining sharp focus on the subject and with the set aperture also remaining constant. The result is a range of image magnifications. For still photography, zoom lenses are available with only a modest

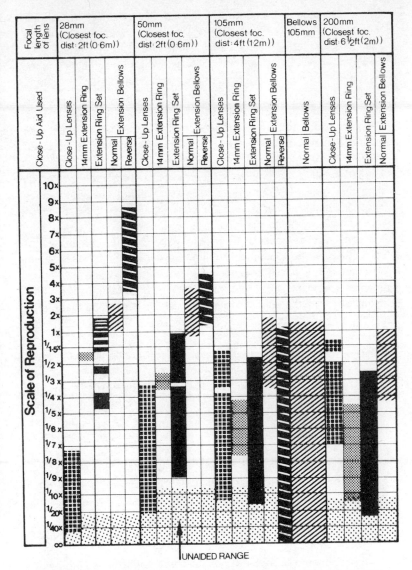

Magnification ranges. For any camera lens the possible range of magnifications depends on the focal length of the lens, its unaided focusing range and the close-up focusing aid used. The diagram shows the possible ways of attaining any given magnification and where these methods overlap.

×2 or ×3 range of focal lengths, covering wide-angle to normal, normal to long focus and long to very long focus types. Typical examples are 28–45 mm, 35–70 mm, 80–200 mm and 200–500 mm ranges. Focal length is changed by a ring which alters the separations of moveable element groups within the lens.

Some zoom lenses have a macro scale mode, and this is operated by a catch on the zooming control or by means of a separate ring. This causes once again moveable elements in the lens to adjust their positions relative to one another, but in a different manner to when the lens is used conventionally.

The net result is that the optical centre of the lens moves towards the subject as the focal length decreases, giving greater effective distance from the film plane. Consequently, the subject plane in focus moves closer to the lens.

Typically, at the closest focusable distance, magnifications of 0.25 to 0.5 are possible with such arrangements. Strictly speaking, this is not a macro mode but a *close-focus mode* as life size reproduction is not possible. This extra facility is essential with many zoom lenses as they do not focus very close in their normal mode, for example two metres (6.6 feet) minimum for an 80–200 mm zoom lens is typical.

The results from macro-zoom lenses are very acceptable especially with subjects where a little distortion or field curvature is not noticeable or objectionable, such as natural history subjects. As expected, stopping down the lens improves resolution but cannot eliminate distortion.

Other advantages include the fact that the lens aperture stays constant in the macro mode. Also the lens has automatic iris operation and couples to the camera metering system.

Such lenses are becoming understandably popular, for if one does not mind its bulk, one lens can perform the functions of several interchangeable fixed focal length lenses as well as close-ups without the need for accessories, just by a simple twist on a control ring.

Other, non-macro zoom lenses can be used with the usual range of close-up accessories such as close-up lenses, extension tubes and bellows. The results may be inferior to those from an equivalent macro-zoom lens.

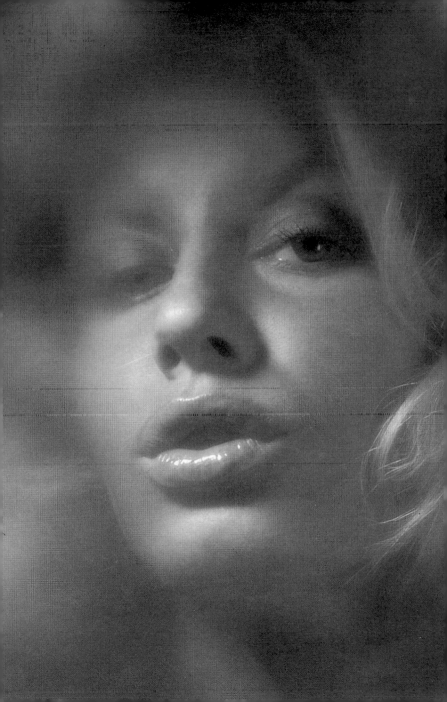

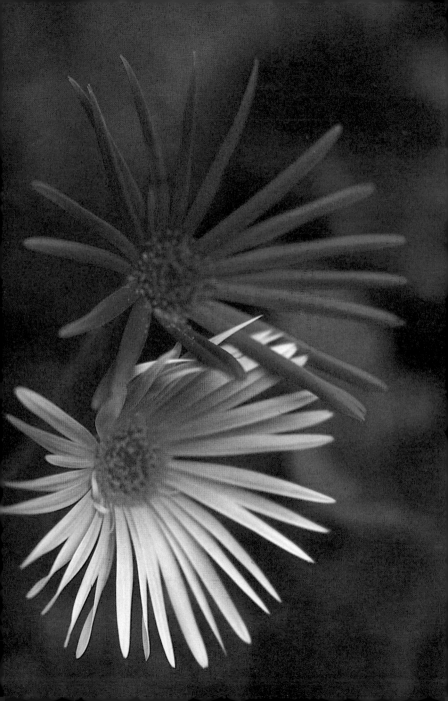

Above: A crane's head photographed with a medium-long focus lens at its closest focusing distance – *John Rocha.*

Opposite: These flowers were photographed using a 55mm macro lens on a 35mm SLR camera. The camera was hand held and natural light was used for exposure – *Percy Poynter.*

Page 65: This unusual portrait was taken on a 6 x 6 cm SLR using a medium-long focus lens together with a short extension tube and a soft focus attachment – *Michael Barrington-Martin.*

Above: A hand-held 35mm SLR camera with a 90mm lens and extension bellows was used to produce this 1:1 close-up of a wasp – *Sidney Ray.*

Opposite: Once again a hand-held exposure was made with a 35mm SLR camera. This time the magnification of $\frac{1}{2}$ was obtained using a 90mm lens with extension rings. A small flash unit was used on the camera and mixed with the daylight (synchro-daylight) – *Sidney Ray.*

Above: The 6 x 6 cm TLR Mamiyaflex camera, with its ability to focus very close without attachments, was used with a 105mm lens focused for 60cm (2 feet) to record this early morning frost. Adjustment was made in framing to allow for the parallax error — *Sidney Ray.*

Opposite: This 35mm transparency was taken with a SLR camera fitted with a 55mm macro lens. The focusing distance was 60 cm (2 feet) and the subject was backlit by daylight — *Sidney Ray.*

Above: Although focused for 60 cm (2 feet) this photograph has an interesting and recognisable background because of the small aperture (*f*16) used – *Sidney Ray.*

Teleconverters for close-ups

The teleconverter attachment is an optical device which is placed between the prime lens on a camera and the camera body. Consisting basically of a short extension tube containing a group of lenses with overall negative power, that is a diverging lens system; its function is to increase the effective focal length of the lens.

Usually it will double or triple the focal length with a corresponding loss of two or three stops in maximum aperture respectively. For example, a 50 mm $f2$ lens is changed to a 100 mm $f4$ with a ×2 teleconverter, and to a 150 mm $f6$ with a ×3 teleconverter. Teleconverters have coupling arrangements so no lens automation is lost. They are small, moderately priced and can give acceptable results at small apertures.

The focusing range of the prime lens is not changed when a teleconverter is added. This therefore gives increased magnifications and quite big close-ups are possible. The results are usually acceptable for most subjects, especially if small apertures are used. In any case experimentation is very worthwhile.

Close-ups from a distance

It is often necessary to take close-up photographs from a distance. This appears at first to be a contradictory statement. But a normal or short-focus lens with a modest bellows extension needs to be close to the subject to give a reasonable magnification. The proximity of the lens to the subject can cause disturbance to subjects such as insects, or may obstruct the lighting. Sometimes, indeed, only back lighting is possible.

The use of a long-focus lens gives much more clearance between lens and subject, although greater bellows extension is needed to give the same magnification as a lens of shorter focal length. Frontal lighting can now be used with no disturbance of the subject. Many workers consider a lens of 135 mm focal length to be ideal. For best results the long focus lens should not be of telephoto construction.

Also, depth of field for close-ups is independent of focal length. So

that at the same aperture and giving the same magnification, lenses of different focal length will have the same depth of field. This is not the case in general photography. Another point is that the longer lens with its more distant viewpoint may give a better prospective of the subject.

Depth of field

Depth of field is defined as the extent of the subject measured front to rear that is rendered acceptably sharp. It depends on the subject distance, lens aperture and lens focal length. In particular, depth of field decreases with increases in aperture (smaller f no.) and focal length, and with a decrease in subject distance. In close-up photography, depth of field can be vanishingly small to the extent of being almost a plane perpendicular to the axis of the camera lens.

As so much close-up photography is done using a reflex focusing system, it would seem a simple matter to judge focus and depth of field at the chosen aperture. Unfortunately, this does not work at all well in practice. At long bellows extensions or large image magnifications, the effective aperture of the lens is small so the image is not bright even at maximum aperture. Further stopping down to a working aperture to view depth of field dims the image even further. For example, at life size reproduction a lens setting of $f11$ is effectively only $f22$.

The provision of powerful lighting does sometimes help but often you are working in dull daylight with electronic flash or with low power studio lamps. Besides, too much light may make the subject aware of the photographer or even cause damage to a heat-sensitive object.

The viewfinder screen may also hinder judgement of depth of field as the central focusing aids often black out at small apertures. The plain ground glass screen is best but the grain structure of the screen must be fairly coarse for accurate focusing and this obscures judgement of sharpness of fine detail.

A compromize procedure is to focus at full aperture on the focusing screen then consult suitable tables of close-up depth of field to help you choose a suitable aperture.

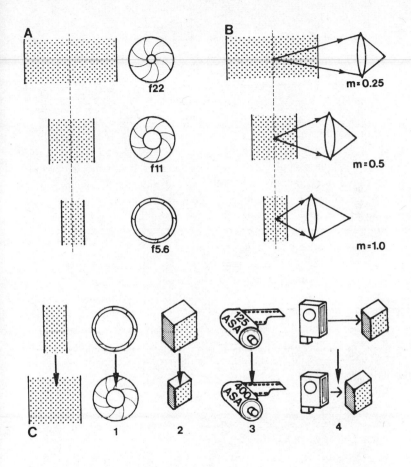

Close-up depth of field. Depth of field for close-ups is symmetrical about the point of focus and its extent depends upon two factors: A. Lens aperture —small apertures increase the zone of sharpness. B. Magnification—an increase in magnification reduces the zone of sharpness. C. To increase depth of field: 1. Reduce aperture; 2. Reduce magnification of the image; 3. Use a faster film to permit a smaller aperture; 4. Increase illumination such as by reducing the distance from the light source to the subject, hence permitting a smaller aperture.

Focusing

A viewfinder screen is commonly viewed by a pentaprism and eye-piece giving a correctly orientated image of the subject at ×3 to ×5 magnification. Alternatively, a focusing hood may be used giving a laterally reversed image. Special high power (×6) magnifying hoods are sometimes available. It is best that stray light is excluded from the focusing screen so a rigid magnifying hood or rubber eyecup on a pentaprism eyepiece is helpful.

Because of the focusing accuracy required for close-ups it is essential that the dioptric power of the eyepiece lens is correct for the user's vision. Many eyepieces can be adjusted by screwing the eyepiece lens in and out, or it may be replaced by an alternative one of the correct value. Adjustment of the dioptric eyepiece to the correct value is by removing the lens from the camera, pointing the camera at a bright, uniformly lit surface, and adjusting the eyepiece until the grain of the screen is sharply in focus. An eyepiece magnifier is a useful accessory at times.

When focusing, you can adjust the lens to film distance, which also alters lens to subject distance and hence magnification. Or, the camera body may be racked in and out on extension bellows with the lens to subject distance fixed, so magnification does not alter. Finally, the lens to film distance may be fixed to give a known magnification and the whole assembly of lens and camera moved bodily to and from the subject until sharp focus is obtained. The use of a tripod focusing rack is of great help for the third method.

If the camera is to be hand held, often with the aid of a pistol grip, then instead of altering the focusing controls constantly hunting for best focus, it is preferable to sway slightly back and fore until the subject appears sharp.

Choice of focusing screen

Some reflex cameras offer alternative focusing screens, which may include those especially for copying and close-up photography. The plain ground-glass screen has many real advantages but requires a fresnel lens at its lower surface to even out illumination, otherwise a central hot-spot is given. It is an excellent all round

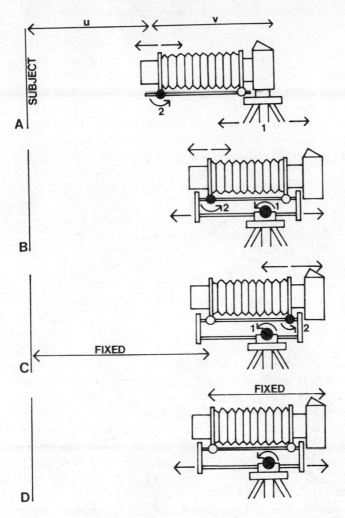

Close-up focusing methods when using bellows units. A1. Coarse focus by moving the tripod; 2. Fine focus by moving the lens; distances u and v are both varied so a given magnification is not easy to set. B1. Tripod focusing rack gives coarse focus; 2. Fine focus is by moving the lens; easier than method A especially for macro focusing. C1. Distance u is fixed by coarse focusing to give a particular magnification; 2. Camera body is moved for fine focus. D. Bellows extension v is set and the camera plus lens are moved together on the focusing rack until the subject is sharp.

choice for close-up work as it gives full screen viewing and focusing. If a scale, grid or engraved circle of known dimensions are also included on the screen, so much the better, as magnification may be calculated and the camera squared up to the subject. This type of screen normally has to be bought as an accessory.

Other screens are of the *mixed* variety. These usually have a central focusing aid such as a *microprism* array or a *split-image rangefinder* device. Surrounding this is a collar of fine ground glass and the remainder of the screen is fine fresnel rings. While excellent for general photography, the focusing aids darken or black out when the effective aperture of the lens drops below about $f5.6$. Since this is common in close-up photography, the darkened central region, which the eye prefers for focusing, is an obstacle to accurate focus. Some through-the-lens metering systems may also be affected and give inaccurate results.

No-parallax focusing

For very critical focusing of very dim images a special viewfinder screen is used. It is a plain ground glass type with a clear central area containing an engraved cross or reticle on its lower surface, that is in the focusing plane. A very bright image is seen in this area, which contrasts with the very dim image in the adjacent area. The cross provides a fixation point for the eye and coincidence of image and cross is determined by the no-parallax method. This merely involves moving the head or eye from side to side slightly. If the image and cross move independently then they are not coincident. If they move together the image is in focus. The method is slow and needs practice. It is only operative for the central area of the screen but it has universal application to the focusing of cameras, microscopes and telescopes.

An ordinary ground glass screen can be converted into one for this technique by marking a cross in pencil on the rough, focusing side and cementing over this, using clear glue, a microscope cover glass or similar. The grain structure is removed, leaving the clear area required for this method.

The use of a high-power focusing eyepiece, that can be critically focused on the cross, is a great help.

The enlarger as a close-up camera

The enlarger may easily be adapted to function as a copying or close-up camera. Various methods of use are possible.

With some subjects, particularly if thin and transparent, they can be treated as a negative and put in the negative carrier on a piece of glass, then projected onto a sheet of film or paper in the masking frame. Even better is to use a camera body without lens and focus on the film using the viewfinder for assistance. Exposure can be then made using the shutter in the camera. Big enlargements of the original subject are possible as the negative produced may be enlarged. For instance, a 50 mm enlarger lens can usually give ×10 enlargement on the baseboard, and the resulting negative can then be enlarged again by ×10 to give a final overall magnification of ×100.

The alternative method is to position the subject, including an original to be copied, on the baseboard and light it as required with the usual light sources. A focusing negative is placed in the enlarger and used to delineate and focus the subject. The focusing negative may be replaced by a sheet of film in a glassless negative carrier and the exposure made by switching on the lights in the darkened room. Some enlargers have a sheet film cassette as an accessory to use in this way but they are expensive. Most enlargers have light tight negative carriers for colour printing so a sheet of film can be inserted in the dark. A piece of black cloth wrapped round the negative stage assists in rendering it light tight to avoid edge-fogging during exposure.

As already discussed, enlarger lenses make excellent macro lenses but camera lenses can often be adapted onto the enlarger lens panel. If they have a built-in leaf shutter the exposure may be given more accurately than by switching on lights.

Perspective

The perspective of a scene is the apparent relationship between the shapes, visual scales and positions of objects in the scene. Perspective is determined solely by the viewpoint, although apparent distortions of perspective can occur in a print and depend

on the degree of enlargement, viewing distance and the lens used. Apparent exaggeration of perspective is given by a close viewpoint which is, of course, chosen to give a particular magnification with the particular lens. Often, a preferred perspective rendering may be given by a more distant viewpoint, and to give the same magnification a lens of longer focal length is required.

Microscope adapter

In principle, any camera can be used with an optical microscope. When the camera lens cannot be removed, the camera must be sited such that the *exit pupil* of the microscope coincides with the iris diaphragm of the lens. The exit pupil is located by holding a piece of translucent paper above the eyepiece and seeing where the spot of light emerging has its smallest diameter. The camera lens must be left at full aperture to avoid vignetting. Correct exposure may be determined by test exposures.

If the camera lens is removable, then the camera body can be attached to the microscope, minus its eyepiece lens, by means of a tube with lens mount and microscope fittings at either end. The image is projected directly onto the film. Focusing if necessary can be by the no-parallax method.

Some microscope adapters have a field lens in their tube so as to give a known magnification on the film related to the microscope magnification. Exposure determination may be by test exposures or by metering methods.

Ancillary Equipment

Essential or luxury items

It has been shown that a great deal of close-up photography can be achieved with very little extra equipment, possibly just with the addition of a close-up supplementary lens. Alternatively, if a macro lens is available then no extras are required for most subjects.

There is available a great range of additional bits and pieces of equipment for photography. Some of these items must be considered as essential, others are luxuries. In the end you must decide for yourself what is essential and what might be dead weight.

Tripod

This essential piece of apparatus is an example of the classic dilemma of practical photography. For a tripod to be of any serious use it should be versatile and sturdy, which means bulky and heavy. Consequently it is not so easily carried out and about. If you want a tripod to be easily portable then it must collapse to small dimensions and be light in weight with the result that it is of limited use. There is no real answer to this problem of stability versus portability. In the end a compromize solution is found.

Height adjustment is most easily done by using a sliding centre column, which is sometimes in two sections. One very useful feature for close-up work is a reversable centre column which allows low angle shots almost to ground level without excessive spread of the tripod legs. The camera is upside down of course but only with a twin lens reflex is viewing difficult. The viewfinder image in an SLR or direct vision camera is seen upright. This inverted arrangement is also very useful for photographing or copying objects laid on the floor beneath the tripod.

The tripod may come with a ball and socket or a pan and tilt head.

A number of tripods offer the facility of interchangeable heads, so a choice can be made. The ball and socket head needs to be large, with a secure locking device, to support a camera and its close-up accessories. While it can be quickly orientated it is not easy to control accurately. The pan and tilt head has separate controls for panning, tilting and rotation allowing precision adjustment. A large camera platform is also provided which gives good support and the best placing of the camera plus accessories.

For indoor use, especially for applications such as copying or portraits, a heavy tripod is recommended.

Table tripod

While not an essential accessory, the table tripod fitted with a small ball and socket head can be very useful. It is light and small and possibly pocketable. Some varieties are available which can be clamped on to handy chair legs or branches, or even screwed into tree stumps as supports.

One great advantage is that very low level shots are possible, convenient for botanical photography. The camera can also get very close to the subject without the tripod getting in the way.

It is also possible to adapt some makes to give a form of shoulder pad or brace which gives additional support for hand held photography.

Pistol grip

The pistol grip attachment, although not essential, can be very useful with hand-held photography that may involve extra equipment. For example, when a flash gun on an extension lead is held in one hand and the camera has to be held, focused and the shutter released with the other. A pistol grip can be a simple holding device or have a direct connection to the shutter release via a trigger arrangement.

Shoulder brace or rifle grip

The design of this accessory is a logical development of the pistol grip to give a rifle shaped cradle to support the camera. It can take

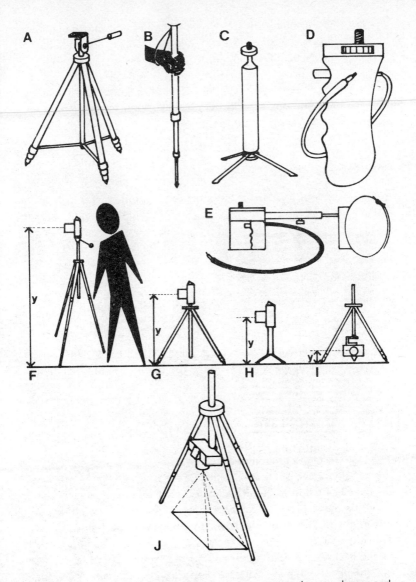

Tripods and supports. A. Tripod with leg braces, centre column and a pan and tilt head. B. Monopod. C. Miniature tripod. D. Pistol grip. E. Rifle type grip. F. Tripod in use; y is the height above the ground. G. Minimum height is limited by the centre column. H. Table tripod. I & J. Reversed centre column.

the form of a skeletal rib with collapsible stock or can be solidly shaped. A trigger release device is incorporated.

While originally meant to allow long focus lenses to be successfully hand held they also give stability and ease of operation for close-up photography. Rapidly moving subjects such as butterflies or insects can be followed and focused more easily when the camera is an extension of one's arms as it were.

Monopod

Yet another form of camera support is the monopod which is a collapsible tube reaching to eye level, fitted with a ball and socket head. It cannot replace a firm tripod but it can give just that extra bit of stability to the camera to give a shake-free hand held exposure down to about 1/30 second; and this of course means a smaller aperture and more depth of field.

Bean bag

This is a small canvas or cloth sack, filled with dried peas or beans so that it can be deformed or shaped to suit the base of a camera. It is useful for low level shots in the absence of a table tripod and when the camera is resting on a delicate surface.

Eyepiece magnifier

A modestly priced accessory available for most system cameras is the eyepiece magnifier which clips on to or screws into the viewfinder eyepiece. It then gives an additional two times magnification of the image seen, but only over the centre of the field of view. This increase, to ×10 from the usual ×5 of an SLR camera viewfinder, is very helpful in determining the exact point of focus.

The magnifier may have variable dioptric settings to suit individual eyesight and allow the screen to be seen sharply in focus. A hinge arrangement is fitted to the magnifier so that it can be swung out of the way and the whole screen image viewed.

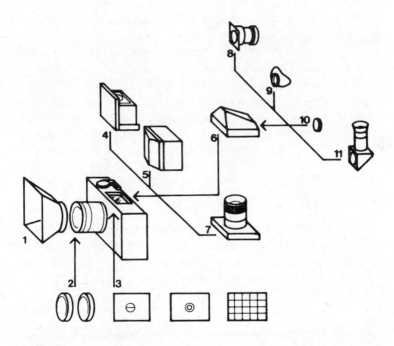

Ancillary equipment. Useful camera accessories and optical aids for close-up focusing include: 1. Lens hood; 2. Filters; 3. Alternative viewfinder screens; 4. Waist level finder; 5. Action finder; 6. Standard pentaprism; 7. Focusing finder; 8. Eyepiece magnifier; 9. Eyecup; 10. Eyesight correction lens; 11. Right angle finder.

Right-angle finders

Some SLR manufacturers produce interchangeable viewfinders, giving the user a choice of waist-level or eye-level viewing. The latter is normally preferred as the pentaprism gives an image that is upright and the right way round.

The waist level viewing mode gives very convenient right-angle viewing and is usually just a focusing hood with a flip-up magnifier. The screen image is the right way up but reversed left to right, and this is the usual situation with a twin lens reflex camera.

For many types of close-up photography a form of right angle viewing is very helpful, especially for low level pictures when the photographer would otherwise have to lie on the ground to view the image. Yet another use is for a vertical viewpoint such as in copying, when the camera is comfortably positioned at eye level for straight ahead viewing while the subject matter is roughly at waist level. The subject can easily be positioned correctly by hand whilst looking into the viewfinder. The image is still reversed of course but the original may be positioned upside down on the copy board so as to appear right way up in the viewfinder.

For those SLR cameras with fixed pentaprism viewfinders an accessory right angle finder is available for attachment to the viewfinder eyepiece. The attachment may be rotated for horizontal or vertical pictures and positions in between. One disadvantage is that the viewfinder image is usually seen at a reduced magnification as compared with the eyepiece alone.

Two varieties of right angle finder are available with differing complexities of optical construction. The simpler, and cheaper, one gives lateral reversal of the viewfinder image. The more complex one uses a pentaprism arrangement to give a laterally correct image. Both varieties usually have a variable eyepiece adjustable to suit different eyesight.

Eyepiece correction lens

Close-up photography requires very accurate focusing and small errors acceptable in general photography are easily noticed even in quite modest close-ups. The variations in human eyesight mean

that the magnifier eyepiece of camera viewfinders may not give a sharp image of the screen. Fortunately it is possible to obtain quite cheaply, suitable dioptric correction lenses to screw into the camera eyepiece. Spectacles may be dispensed with in many cases allowing a better view of the whole screen area.

Cable releases

A cable release is an essential item to permit shake-free operation of a camera shutter for exposures longer than about 1/30 second. There is a wide variation in the types, length and durability.

When a very long connection is required between operator and camera a cheap and useful variety is the air piston type which is of very old design and origin. A rubber bulb is squeezed at the end of a piece of rubber tubing, up to some ten metres (33 feet) in length, operating a small piston in a cylinder attached to the shutter release button. Such devices are very useful for natural history photography especially if some form of motorized wind-on is available.

A simple wire type of cable release should be at least 30 cm (12 inches) long to prevent vibration from the operator transferring to the camera. When using the shutter B setting, a locking device on the cable prevents a sore thumb and possible camera shake.

A special variation is the double cable release which has a pair of long connections operated by a single plunger. The stroke of the two releases may be altered independently. The usual application is to operate the iris mechanism on a lens attached to a bellows and release the shutter just subsequent to this action, with a single press on the plunger. Thereby full aperture viewing and focusing is possible.

Long exposures impose a risk of vibration during the shutter operation sequence and the duration of the exposure. Apart from using a long cable release and a heavy tripod, there is another technique to reduce shutter jar involving a card covered in black velvet. First, if this is possible, raise the camera reflex mirror. Then carefully position the card in front of the lens but not touching it, open the shutter and allow several seconds to elapse before removing the card baffle. Commence timing the exposure on removal of the card

and terminate it by placing the card once again in front of the lens. Finally close the shutter.

Some advanced designs of electronic cameras use a simple electrical switch, electrical cable connection and plug instead of the traditional cable release.

Auto winder

An auto winder will wind on the film to the next frame on release of the actuating pressure on the shutter release button. They are compact, if rather heavy, and usually attach to the baseplate of the camera. They are significantly cheaper than the more versatile, specialized motor drives.

This auto winder device is undoubtedly a luxury item, but it has a useful application in close-up photography. For example, if, after patient stalking you have a feeding butterfly in close-up and one shot is taken, then the sudden series of movements to wind on the film may startle the subject. Additionally, the camera is moved and focus is momentarily lost. Absolute stillness of the photographer plus an auto winder may enable a series of pictures to be taken. It is also easy to 'bracket' exposures when using an auto winder.

A further application of the auto winder is when taking a series of close-ups of shy subjects such as nesting birds by remote release. Long cable releases, air releases, electrical solenoid devices and ultra-sonic devices may all be used to actuate the shutter.

Filters

There are a few points worth noting about the use of filters in close-up photography. They are normally fitted in front of the camera lens by means of a push-on, screw or bayonet fitting. A lens hood is then fitted in front of the filter or it may have its own separate fitting around the rim of the lens barrel.

With a close-focusing macro lens, filters are fitted as normal. But if a lens is used in reverse mode, by means of a reversing ring or such like, then because the filter cannot be fitted to the lens mounting an additional adapter ring is needed.

An important point to remember is that if a close-up supplementary lens is used, it must be positioned next to the lens front element and then the filter, including ultra-violet filters, attached to it. Most supplementary lenses have male and female fittings for this purpose for they are often used in tandem to give greater power. In this case the more powerful of the two is positioned closest to the lens.

A particularly useful filter is the *neutral density filter* which has no colour but absorbs the light evenly throughout the spectrum thus cutting down the light reaching the film. For convenience they are usually available with filter factors of ×2, ×4, and ×8. They are used in close-up photography when a powerful electronic flash gun, which does not have a reduced power setting, is used close to the subject. The neutral density filter will prevent the film being over-exposed.

For full information on the use and properties of all sorts of filters, the FOCALGUIDE TO FILTERS is recommended.

Lens hood

The contrast reducing effects of *lens flare*, which is stray, non-image forming light in a lens, is greatly reduced by lens coatings, especially multi-coatings, but is still significant when caused by a bright source of light outside the picture area. An efficient lens hood can exclude such unwanted light.

For close-up photography the situation is slightly different. The lens when focused close is covering a smaller angle of view, so the lens hood satisfactory for infinity is less efficient for close-up work, being too short. Also, when the lens is very close to the subject or when a ring flash is in use, the lens hood if used will cast shadows or prevent light reaching the subject. Consequently, it is often best to dispense with a lens hood for big close-ups.

Exposure log book

A most useful practice is to record all relevant exposure details of a subject in a suitable log book or note book. It is possible to obtain these specially printed or a plain one can be used with suitable ruled columns.

While initially it may seem tedious or time-wasting to do this for every exposure, after a time this log book becomes a valuable reference source as to details of tests and experiments, lighting arrangements, development and so on. It is even more useful if comments on the results are added at a later date.

Outfit case

When using an outfit case the temptation is to fill it with everything photographic you possess, but after a while the weight proves a damper to active photography.

When lengthy field trips are contemplated, the case should be light but with sufficient rigidity to protect the contents from buffeting and also waterproof enough to withstand being upon wet ground. It should also be large enough to take the camera with say extension bellows attached for rapid access. This also allows the camera to be put away quickly should it start to rain or if both hands are needed for climbing.

Another type of case has a foam-filled interior which can be cut away to hold equipment. This allows very safe transportation and storage but they are not lightweight or compact enough to carry around for casual use.

Equipping for a field trip

A trip out with the intention of doing some close-up photography can be very casually arranged in that supplementary close-up lenses can be slipped into the pocket or a macro lens fitted to the camera.

On a slightly more deliberate level, a small electronic flash gun can be slipped into another pocket to simplify any exposure problems. A tripod will be found essential or just a nuisance to carry round, as has already been discussed. A reversible column or table tripod permit low angle shots in which case a right angle finder may be helpful. An item often overlooked is a plastic sheet on which to kneel or lie for low level shots, especially on damp ground. Miscellaneous items such as an exposure log book and pieces of paper or plastic to serve as backgrounds or windbreaks for subjects

such as plants or flowers, are easily tucked into a corner of the case. A small torch can greatly assist focusing in poor light or at small apertures.

But, as usual, the temptation is to take all your available equipment and stagger about with a full outfit case. Between these two extremes a sensible yet versatile collection of equipment can be compiled for a short field trip.

Equipping the home studio

One of the great attractions of close-up photography is that a very versatile home studio can be set up in a very small space. Close-up photography needs only a couple of square feet of space such as the top of a small table plus the floor area covered by tripod legs.

Backgrounds or backdrops are easily devised from coloured paper or even better from pieces of cloth. The low weight of the background makes positioning very easy.

Light sources can be one or two small electronic flash guns, desk lamps or even a slide projector. Shaving mirrors, small mirrors, or pieces of white card make very good reflectors and are easily clipped or fastened in position. Diffusers are simply built from pieces of translucent paper such as greaseproof or tracing types. Special items such as diffuse light sources can be made from truncated cones of paper or white plastic cups with the base removed.

Small blocks of wood, pencil erasers, lumps of plasticine and similar items are useful for positioning subjects. Also small sheets of glass are ideal for supporting the subject when it is essential to separate it from the background, but beware of reflections. A small light box can be made using miniature fluorescent tubes as light sources.

All sorts of domestic items can be pressed into service with a bit of ingenuity, for example, crumpled kitchen foil makes an excellent reflector or an unusual background.

Lighting The Subject

Purpose of lighting

Apart from the primary function of providing light on the subject of sufficient quantity and the correct quality, the light source or sources are also used to show the shape, form and detail of the subject.

Careful use of lighting permits you to either enhance or subdue detail. For example the texture of the subject may be emphasized by strong side lighting or almost removed by even frontal lighting. Contrast may be increased or even decreased by balancing the main light and filling lighting so as to suit the film material and the result required.

Quantity of light

The prime consideration is that the amount of light is sufficient to enable an exposure to be made under the desired conditions. For instance, hand-held camera exposures require a certain minimum exposure time to prevent camera shake. This exposure time and the prevailing lighting conditions will determine the necessary aperture. Also, the depth of field requirements may force the use of a tripod or of a faster film.

When electronic flash is used close to the subject, there may be too much light, and the lens cannot be stopped down far enough to prevent over-exposure. Neutral density filters are useful in this situation.

When there is inadequate light, there are various alternatives to consider. One is to use flash for illumination but this may destroy the existing lighting that makes the subject attractive. The use of a tripod permits exposures of any duration but a hand-held camera is mobile and permits a rapid change of viewpoint.

Also the use of a long exposure time may show subject movement or a colour shift in a colour transparency due to the effects of reciprocity law failure.

Quality of light

The quality of light falling on the subject is a separate concern from quantity. The quality can be expressed as the *spectral energy distribution* or the *colour temperature* of the light source. The latter is defined as the temperature to which a perfect emitter of radiant energy must be raised in order to match the light source. The unit used is the Kelvin (K). Photographic light sources are quoted in Kelvin and colour films are available balanced for a particular colour temperature.

Concern with colour temperature is not important with monochrome films but essential when dealing with colour films. For example, daylight colour slide film, which is balanced to give correct rendering with daylight, electronic flash or flashbulbs, will give reddish-orange results with tungsten lighting. Also, the quality of daylight can vary enormously depending on the time of day, the season and the latitude. Light balancing filters may be needed for photography in the early morning, late evening, in winter sunshine or deep shade.

The quality of a flash source is consistent, as is its output, making it an ideal source for many types of photography. Film balanced for daylight should be used. Other varieties of colour film are balanced for tungsten lighting such as studio lamps or photofloods. It is possible, by the use of colour conversion filters for film balanced for one light source to be used with another. Of course, allowance must be made for the filter when calculating exposure.

Mixed lighting refers to the use of two or more light sources of widely differing colour temperature, neither of which may be correct. This situation must be avoided where possible with colour film but black and white materials are relatively insensitive to such variations.

One case where different but largely compatible light sources are used is when electronic flash is used to provide fill-in lighting for sunlit conditions.

Lighting problems

Apart from the usual problems in lighting for photography of choosing the type and form of lighting for the subject, close-up photography has one or two problems all of its own.

A serious problem is the proximity of the source to the subject. Tungsten lighting is excellent in allowing the effects of lighting to be judged visually, and it is easy to make adjustments. But the heat emitted by the light source may cause discomfort to the subject, actual physical damage, or cause alarm and increased activity in subjects such as insects. Precautions, such as the use of glass tanks of water to act as a heat filter, are often necessary.

Electronic flash can give problems of uneven illumination of the subject as the combination of flash tube and the shape of its polished reflector are designed to give approximately even coverage of light at minimum distances of about one metre (three feet). Closer distances can show up 'hot-spots' of illumination. Some form of diffusion may be necessary.

Automatic electronic flash units may not function correctly at short sensor-to-subject distances, as the response time of the electronic circuitry may be too long to permit the flash discharge to switch off when the correct level of exposure has been reached. Consequently the subject is over exposed as the light pulse is too long. This problem can be overcome by putting a diffuser or neutral density filter over the flash reflector so as to cut down the light emitted and allow the photocell to operate efficiently.

Yet another problem for the large close-up is that the camera lens may have to be positioned so close to the subject that it is difficult to place light sources in their ideal positions. One answer is to use a ring-flash source around the lens but even this has certain limitations. Indeed, for many forms of macrophotography at high magnifications, only transparent specimens may easily be photographed without the aid of complex and specialized lighting devices.

Lighting and shadows

With the exception of subjects that are basically flat in nature, such as documents and prints, or reflecting such as metal surfaces, much

of the lighting control and manipulation for photography is to determine the size, position and density of the shadows cast by a three dimensional object.

The shadows cast by or on a subject are a major factor in defining or giving clues to its shape, form and texture. If shadows are not properly controlled they can be most distracting and aesthetically displeasing. The shadow of a stray branch falling across a face may not be noticed when looking at the scene, but it will assume greater prominence and disturbance in a photograph.

For a three dimensional subject positioned in front of a suitable background, the shadows produced are functions of the lighting used, the shape and size of the subject as well as the distance from the background.

Most lighting situations use a *main* or *key light* to provide much of the illumination as well as to produce the desired effect. Then, because photographic materials with limited exposure latitude usually cannot accommodate the resultant high *subject brightness range,* which is the difference in brightness (luminosity) between shadow and highlight; some means of softening or lightening the shadows is needed to reduce the contrast of the scene.

This *fill-in light,* as it is called, may be a reflector to redirect light from the main source into the shadow areas. More often it is a second light source which gives an even flood of light over the subject and is positioned near the camera. The key light is usually positioned well off the subject camera axis.

Finally, some form of effects lighting may be necessary for the particular subject. Common examples are highlighting some part of the subject, rim lighting to give separation from the background and light on the background.

Source size and distance

The type, size and brightness of the shadows produced by a light source depend upon the size of the light and its distance from the subject.

A small source will give deep, hard-edged shadows and thereby contrasty lighting. As this small source is moved further away from the subject the shadows get smaller. As the source is moved

progressively off the camera-subject axis so a hard deep shadow is cast to one side of the subject. A small electronic flashgun is a good example of such a source. Another example on a larger scale is a spotlight.

As the source size increases, the hard, deep shadows become edged with lighter, soft-edged shadows which progressively dilute the former. The use of a large, diffuse light source gives a combination of deep and light shadows merging together, often in a most pleasing manner, and can be used without any other lighting. Examples of such sources include large flood lamps and the combination of an electronic flash gun with a silvered umbrella shaped reflector, often called brolly-flash. The exact nature and shape of the shadows depends of course on the size and distance of these sources from the subject.

The key to lighting in close-up work hinges around the relative sizes of the diminutive subject and the dimensions of available lighting units. As an illustration, when a small object of say 75 mm (three inches) high is photographed using a small one-piece electronic flash gun of smaller size, then this would constitute a relatively large light source. Consequently, it would tend to give a softer form of lighting than might be expected; although some uneven coverage due to reflector design may occur. Taking the flash gun further away would reduce its effective size.

Another possibility is that the light source may have to be positioned well to one side of the subject due to the proximity of the camera lens to the subject. Strong side lighting or top lighting may then result, requiring some form of reflector or fill-in lighting.

On occasions, soft even lighting can only be obtained by means of a ring-flash around the camera lens. This is particularly true when photographing metallic or polished objects.

The normal size of a flood light and reflector is so very large compared with the subject that it is very inefficient due to the spread of light. Also the lighting produced is very soft. Even a focusing spotlight when fully spotted down covers a comparatively large area, albeit more efficiently, but can give more contrasting lighting by its directional properties.

Indeed, and luckily for the amateur photographer wishing to equip a home studio for close-up photography, small desk lamps and

miniature spot lamps are often more convenient and efficient to use than the much larger photographic lighting units. Slide projectors and microscope lamps can also be used.

We will now investigate the relevant properties of various light sources and their usefulness in close-up photography.

Daylight

Daylight is an extremely variable light source in both quality and quantity. It is just these variations that make it such a wonderfully creative tool in photography. The choice of the appropriate time of day and weather will produce mood and atmosphere in a photograph.

While daylight can be utilized very successfully for close-up photography out-of-doors, it is also prudent to have at hand an alternative source such as an electronic flash gun.

Daylight is usually considered as being a mixture of sunshine plus some clouds; a standard mixture with a colour temperature rated at 5,500 K is called *photographic daylight* and is the value to which daylight type colour films are balanced. But daylight can vary from complete overcast conditions which can be dull or bright with a complete absence of shadows, to full brilliant sunshine giving deep, hard shadows. This latter form of daylight can be a problem with colour reversal film which can only accommodate a limited subject brightness range. Some form of fill-in lighting is required and this is conveniently provided using electronic flash and the technique of *synchro-sunlight*. This is an example of where mixed lighting is possible as the sources are compatible. Camera exposure is based on the sunlight conditions to give an aperture and shutter speed combination suitable for synchronisation with electronic flash, which is then positioned at a distance or adjusted (automatic models) to suit the chosen aperture.

Daylight can change very quickly in quantity; for example on a windy day with sun and clouds the exposure can alter by several stops within a short time period. This usually occurs just as the shutter is released on a carefully aligned close-up! In the late evening as the sun sets, the light level drops very rapidly.

The colour quality of daylight also varies rapidly at dawn and

sunset but it is also dependent on the season and weather. Colour temperature drops in the evening, rises in the morning, is low during winter and is very high in overcast or rainy conditions. Even on a sunny day, subjects in the shade receive mainly light from a blue sky so that results on colour film have a 'cold' colour balance. Fortunately, light balancing filters can offset most of these effects if need be.

Flashbulbs

Flashbulbs for amateur use are normally used as a small bulb in a reflector, fired by a suitable battery capacitor circuit; or as multiple bulbs fixed in an array, such as a *flashcube* or *flash bar* arrangement, fired one at a time until exhausted.

As a light source for general photography the flash bulb has many advantages. The light output is high, useful for simple cameras with lenses of small aperture, and of a constant quality and quantity. The necessary apparatus is small, light and easy to carry around. The only disadvantage is the cost per bulb.

Many cameras, especially of the simpler low-cost variety, may have no provision for the use of electronic flash and only flash bulbs can be used. Sometimes a special adapter can be purchased to allow electronic flash to be used as an alternative and, in the long run, cheaper light source.

For close-up photography the flashbulb may have an output that is embarassingly high for the proximity of the subject—a small flash-bulb is equivalent in light output to a large portable electronic flash unit. Much of this light, however, does not reach the subject, but spreads over a large area.

The special close-up kits available for simple cameras are designed to overcome these problems. A diffuser or neutral density filter attachment is supplied to fit over the flash reflector to cut down the light and an accessory reflector may be used to redirect the light down towards the subject.

With rare exceptions, there are no automatic exposure systems for flash bulbs as exist for electronic flashguns. A series of exposure tests are needed to determine optimum exposure with close-up attachments. The exceptions are cameras such as the Olympus

OM-2 and some Polaroid cameras which incorporate auto-exposure devices with electronic shutters.

Tungsten lighting

The traditional alternative to the use of daylight for photography is some form of incandescent tungsten lighting. While this form of illumination is very widely used, it is rapidly being displaced by electronic flash, especially for close-up photography of delicate or fast-moving subjects.

Studio lighting in its traditional form is available as spotlights or floodlights, using lamps with a colour temperature of 3,200 K suitable for type B colour films. The lamps are rated at 500 watts or greater. These units are heavy and durable, mounted on cumbersome stands. The more modern tungsten-halogen units are much smaller, lighter and consequently transportable.

The usual light sources for the amateur are bulbs of the *photoflood* variety. These have a high intensity with a short life. Their colour temperature is 3,400 K as they are meant primarily for use with type A colour films. The high intensity can give severe heating problems with some subjects and you may have to use an alternative light source. The short life of photofloods (and other lamps) can be greatly extended by use of either a thyristor dimmer switch of the correct rating, or by use of a series-parallel switch for two lamps to give half power initially. Both methods reduce the chance of the filament breaking from the initial surge when switching on the lamp.

Photofloods are essential to maintain the correct balance for colour film but they can be replaced by domestic lamps of much lower rating for black and white films. Apart from the lower cost and long life, such lamps have much lower heat output.

While the leisurely inspection of the lighting effects possible with tungsten lighting is an ideal method of photography, it has obvious disadvantages with some subjects which may be animate or which suffer from prolonged heating. Also the necessary exposure time may be so long that subject movement is possible.

Apart from these obvious problems, which do not matter much for applications such as copying and slide duplications, a major

difficulty is the large size of the source which may mean it is poorly sited or inefficient.

Miniature spot lamps

A range of functional and decorative lighting units for domestic use are available in the form of miniature spot lights using small bulbs, often with internal silvering. A more efficient form is a reading lamp or desk lamp with flexible swan-neck mounting or with universal jointing.

Such light sources are very useful for close-up photography because of their small size and ease of positioning. The use of colour film can be a problem as photofloods of the correct colour temperature cannot normally be used with such units because of overheating and difficulties of insertion. So their use is really limited to black and white film or as a handy modelling lamp for setting up electronic flash. They are also useful to provide local lighting for focusing.

A useful copying set-up can be arranged using two or preferably four of these lamps. The desk lamp type can sometimes tolerate a small number one photoflood bulb switched on for short periods only.

Microscope lamps

Microscope lamps consist basically of a small tungsten filament run at a low voltage which is variable to give different light outputs. A focusing lens and iris diaphragm permit a circle of light to be imaged on a small area.

While being a specialized piece of apparatus and rather costly, such a lamp is absolutely ideal for many applications of close-up photography and may well be worth considering. At full power the colour temperature is 3,200 K. Heat filters can be fitted to protect the subject.

Slide projector

Since many amateur photographers also possess a slide projector this can often be pressed into service to give a versatile light source

for close-up photography. It gives a high light output of colour temperature 3200 K, suitable for colour films, with heat filtration provided internally. The lens may be focused or possibly be interchangeable, allowing variation in the area of subject illuminated.

The slide projector acts effectively as a spotlight and gives dense, hard-edged shadows. Some form of reflector or fill-in light is usually also required.

One precaution is that the projector must not be used with its optical axis tilted excessively from the horizontal or there may be a danger of the bulb blowing. For non-horizontal illumination, mirrors may be used to reflect and steer the beam of light into the necessary orientation.

Electronic flash

The electronic flash is perhaps the ideal light source for most close-up photography. Its primary attributes are constant colour temperature (approximately 6000 K), constant light output and the relatively low cost. Also of significance are the ability to stop motion, with flash duration of 1/400 to 1/50,000 second, and the independence of a mains power supply. In addition, modern units are easily carried.

The flash is initiated by a suitable triggering circuit which is connected by a synchronization lead to the camera shutter. The circuit is made when the shutter operates. Alternatively, *open flash* may be used if the camera has a B setting and the flash fired once or repeatedly by means of a test button. This open flash technique must be done in a darkened room of course, and is useful on occasions when several flashes may be needed to build up enough exposure or if an unsynchronized microscope camera body is being used.

As is well known, a between-lens or leaf shutter is synchronized with electronic flash, even up to top speeds of 1/500 second. The arrangement is that the flash contacts close when the shutter blades are fully open, the flash firing virtually instantaneously before the blades begin to close. This form of synchronization, termed X, is a great convenience for close-up flash photography in daylight, when the shutter speed is chosen to give adequate

exposure to the background and the aperture is chosen to suit the flash illumination of the subject.

Synchronization of the flash with focal plane shutters is not so convenient as the flash must occur when the film area in the gate is fully uncovered by the shutter blinds. Usually the maximum shutter speed for this condition is only 1/60 second, and it may be as low as 1/30 second for a medium format camera or as high as 1/125 second for some designs of shutter.

Control of the background exposure in daylight is not so easy as with a leaf shutter, and often double images or ghosts of the subject may appear if the ambient lighting level is high enough. The primary exposure is from the flash unit and the secondary exposure from the ambient lighting.

One great advantage of modern electronic flash units is that they are small and light while giving more than adequate output for close-up photography. Their size makes positioning of the unit a relatively simple matter.

An additional flash unit or extension unit may be fired simultaneously with the main flash by means of a connecting lead or a *slave cell.* No leads are required to the slave cell, which is connected to the synchronization outlet of the extension unit. A photo electric cell closes the firing circuit when activated by the change in ambient light level as the main flash fires. A whole range of lighting effects are possible in this way including the provision of fill-in lighting to back lighting for location subjects.

An alternative mounting position for a flash gun instead of on the camera is on a flash bracket or handle grip at one side of the camera. Normally, synchronization is by flash lead only. The light from the flash in this position is more off axis than previous, so more modelling is given and the lighting is more contrasty. The shadows may have to be filled in by reflector or another near axial flash gun.

A possible problem with close-up work is uneven illumination if the subject is positioned near the edge of the flash coverage. This applies when the flash is pointed straight ahead of course, but a small swivel or ball and socket head mounted on the bracket allows the flash gun to be pointed downward and sideways to direct light at the subject.

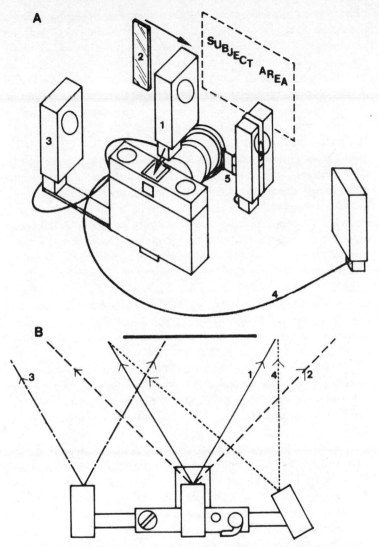

A. One or two electronic flash guns may be positioned: 1. On the camera; 2. With a diffuser; 3. On a flash bracket; 4. With an extension flash lead; 5. Using a slave unit for a second flashgun. B. The flashgun may or may not illuminate the subject evenly: 1. On camera—satisfactory; 2. On camera with diffuser—satisfactory; 3. On a flash bracket—may not cover; 4. Angled towards subject—satisfactory.

Sometimes it is necessary or convenient to position the flash gun very close to the lens axis and there are various ways and means of doing this. One very elegant method is to use a Novoflex X shoe which screws into the filter thread of the lens. A small flash unit can be attached, swivelled and positioned as required then locked in position above or to one side of the lens. Two flash guns can be attached in this manner. Alternatively, it is often possible to fix or tape a small flash gun to the lens hood or lens barrel.

Automatic flash guns are a great convenience for general flash photography but for close-up work a few points are worth noting. The principle of the automatic mode is that a photocell monitors the light reflected from the subject during the flash exposure. When, according to preset conditions, enough light has been emitted to give correct exposure for the average subject, the flash discharge is quenched by a suitable electronic switch. Automatic operation typically is over a range of 60 cm (two feet) to six metres (20 feet), and a choice of one to four alternative aperture stop settings may be given.

It is important to remember to set on the flash calculator the *effective aperture* of the camera lens according to the subject magnification, see page 136. This chosen value according to depth of field and lens performance may or may not correspond with the one or more suitable apertures indicated by the flash gun for the film speed in use. So some compromise may be necessary by adjusting the lens aperture to a suitable setting for the flash gun.

The automatic feature may not operate well at close distances due to the reaction time of the electronic circuitry and give too long a flash duration resulting in over exposure. A diffuser may be useful here as it also helps spread the light output to give even coverage of the subject at close distances.

Certain automatic flash guns offer the ability to select fractional light output as an alternative to full power. Normally this operates in halving steps down to 1/32 or even 1/64 of full power. The automatic mode of operation cannot then be used and tests are necessary to establish correct exposures.

Finally it must not be forgotten that convenient as flash is to use, its major disadvantage is the inability to judge lighting effects and shadow positions in the absence of modelling lamps. Occasionally

it is possible to set up with small tungsten sources and replace them by the flash units before exposure. Small lamps may even be taped to the flash guns themselves but at best these methods give only an approximation to the final effect.

Studio flash units

The rapid development of electronic flash designs has produced some excellent units primarily for studio use, at modest prices not out of reach of the amateur photographer. Their usual use would be for portrait work and suchlike.

The output of the smaller units is of the order of 200 joules, which is comparable to the output of larger portable electronic flash guns. One of their most useful features, and the reason why mains or generator operation is required, is the provision of modelling lights. These usually are in the form of a small photoflood lamp, integral with flash tube. With experience, lighting effects can be set, judged and modified.

The large size of the unit plus reflector, means that their lighting is soft with very diffuse shadows. This type can be used very successfully for moderately close-up photography in the studio, especially still-life set-ups. Large close-ups or macrophotography pose the unusual problems of getting enough light on the subject as the lights cannot get near enough and much light is lost by the large coverage from the reflectors.

Ring flash units

One type of electronic flash unit that is produced especially for close-up photography is the ring flash, whose flash tube is circular instead of the usual linear shape. The flash tube fits around the lens, and produces light that is soft, even and shadowless.

A ring flash is especially useful for subjects with metallic reflecting surfaces and intricate fine detail in depth; for example the interior of a mechanical watch. It is also relatively simple to light evenly shallow cavities such as the inside of the mouth for dental photography.

There are, however, objections to the use of ring flash due to the

very flatness of the lighting which destroys all three-dimensional effects, and to the reflected image of the flash tube on glossy surfaces. Often the simple small flash gun positioned close to the lens is preferred and the presence of shadows gives useful clues to the perception of shape.

The ring flash may be purchased as an accessory head to an existing power pack whether for a studio unit or a portable unit. In such cases the flash output (even at reduced power) is usually far too great for convenience in close-up work. The size of the flash head may be quite big as well.

Specialist ring flash units with a suitably low output, are available powered from compact battery packs. Sometimes it is possible to reduce the power by a switching arrangement. The flash tube is light weight and does not substantially affect the balance of the camera and lens. Nor does it protrude much in front of the lens, allowing a close approach of the lens to the subject.

One problem which can arise is flare light from the flash tube due to its position and proximity to the camera lens. An anti-flare baffle may be required; this device looks like a shallow lens hood and can be supplied with the unit.

Ring flash units are not automatic in operation and the user must carry out his own series of exposure tests based on data supplied by the manufacturer. The illumination coverage of a ring flash may be specific to a particular magnification and subject distance; alternative units of different diameter may be required for different conditions.

Apart from the comments specific to these flash units all the other properties of electronic flash as described previously are the same.

Ring light

For the home studio, a useful light source that can be made by the handyman is a ring light unit. This is a larger form of ring flash, but is of continuous operation allowing inspection of lighting effects. Also, long exposure times may be given allowing the use of small apertures to give depth of field.

The unit is made from a domestic fluorescent light tube which is available in circular form and may be fixed in a suitable holder with

a white card reflector. The camera is aimed through a central hole of the ring light. Such a light source is relatively cool and inexpensive to make and is operated from the electric mains supply. The unit is suitable for dark-field lighting, see page 119.

Because of the unusual spectral energy distribution properties of fluorescent tubes, its use with colour film may not be possible without some form of corrective filtration. No such problems arise when it is used with black and white film.

Heat problems

With most forms of incandescent lighting the nearness of the light source can cause heat damage. Glass heat-absorbing filters may be used or a glass tank of water interposed between light and subject to act as a heat barrier.

Electronic flash guns also emit a pulse of heat as well as light, but it is of short enough duration to have little effect unless it is fired in contact with something such as the skin or polished wood, when a burn may result.

Types of lighting

It is well known that axial front lighting, that is light directed along the axis of the camera lens, suppresses subject texture. By comparison, side lighting emphasizes these very features and gives a pronounced textural rendering of the subject.

In most instances, the subject itself dictates the choice of lighting, although for some circumstances in close-up photography there really is no choice. For example at high magnifications in macro-photography only transmitted light is a feasible method, due to the closeness of the lens to the subject and the minute depth of field; so the subject must be thin and translucent.

While the positioning of the light source or sources plus ancillary aids such as diffusers and reflectors is critical for every individual subject and is a creative control, the type of lighting used can normally be categorized into a few basic types. These include: *direct, diffuse, axial, transmitted* and *dark field lighting*.

It is useful to look at each of these types in turn and see how they can be achieved and manipulated.

Direct lighting

As the name implies, this type of lighting is by direct illumination from the light source. It also implies that the lighting is frontal. The light source is usually positioned above and to one side of the camera and may be in front of or behind the camera position. The normal idea with such lighting is to simulate direct sunlight.

As previously stated, the change of the main light from axial or near axial to side lighting, brings a steady increase in textural rendering. Also, the smaller the angle subtended by the source at the subject, the harder and deeper are the shadows.

A small electronic flash gun on the camera accessory shoe or on a short flash bar is a good example of direct frontal lighting, normally giving acceptable lighting for much close-up work as the effective source size offsets the directional effects.

For many subjects stark delineation of detail and deep, unrelieved shadows are unacceptable, that is the lighting ratio used is too high. Lower contrast may be given by various alterations to the basic direct lighting. Of course with black and white films the contrast can be changed by varying exposure and processing.

The usual change to the lighting is to lighten the shadows while retaining the lighting effect. A simple method is just to put some form of diffuser over the light source, but this cuts down the light output considerably, perhaps by the equivalent of one or two stops of exposure or more. Various items are pressed into service as diffusers including white handkerchiefs and tracing paper. It is obviously easier to have the diffuser fixed in position over the source to allow the camera to be hand held if need be.

An alternative method to the diffuser is to use a simple reflector to direct some light from the source into the shadow regions which receive no direct light. Sometimes this may mean the aid of an assistant or some means of fixing the reflector so that the subject is not disturbed. Reflector materials range from ordinary white card or paper to hand mirrors or flexible sheets of kitchen foil.

Another method of reducing contrast and possibly the most versatile when the craft is mastered is to use another light source. If this second source is of the same power and properties as the main, or key, light then control of lighting is absolute. The relative

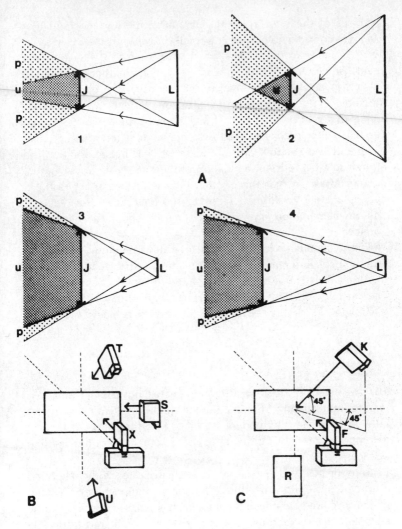

Direct (frontal) lighting. A. The distance of the light source L and its size relative to the subject J determine the nature of the shadows, u indicates hard umbral shadow and p soft penumbral shadow. 1. Soft edge shadows; 2. Very soft shadows from a large source at the same distance; 3. Hard shadows from a small source; 4. Very hard shadows as the source distance increases. B. Single source. T top lighting, S side lighting (texture lighting), X near axial lighting and U bottom lighting. C. Two sources—single light K can be softened by a fill-in light F or a reflector R.

distances of the two lights will determine the lighting ratio. For example, consider two lights of equal power with the fill-in lamp twice as far from the subject as the main lamp. Because of the inverse square law of illumination—which shows that illumination falls off inversely proportional to the square of the distance from the subject—the illumination level on the subject from the fill-in light is one-quarter the value of that given by the main light alone. The fill-in illuminates the shadows. The illumination ratio between directly lit and shadow areas is therefore 4:1, but in addition the fill-in also adds to the illumination of the directly lit areas with its quarter power so that the lighting ratio is in fact 5:1. The fill-in light is usually positioned close to the lens axis so as to give uniform illumination and prevent its own shadows being pronounced.

The fill-in lamp adds to the general level of illumination, and therefore the exposure may be reduced relative to that needed without the fill-in. This is not the case when a diffuser or reflector is used. The majority of close-up subjects may be photographed using direct lighting. Highly reflective or transparent subjects are exceptions.

Diffuse lighting

The characteristic of diffuse lighting is that the subject does not receive light directly from the source, but via reflection or transmission by some intermediate surface. This then gives a kind of lighting that depends on the nature of the reflecting or transmitting surface.

Perhaps the best known example of such an indirect form of lighting is when a flash gun is used in a bounce flash mode, when instead of being pointed directly at the subject, it is pointed at some nearby suitable reflector such as a ceiling, wall or even a shirt front. The light now comes from a very large light source, hence the lighting is low contrast with soft shadows. The inevitable penalty of this form of diffuse lighting is a drastic loss of light, equivalent to one or more aperture stops increase in exposure.

In the case of automatic flash guns it is essential that the photocell or sensor points at the subject irrespective of the orientation of the

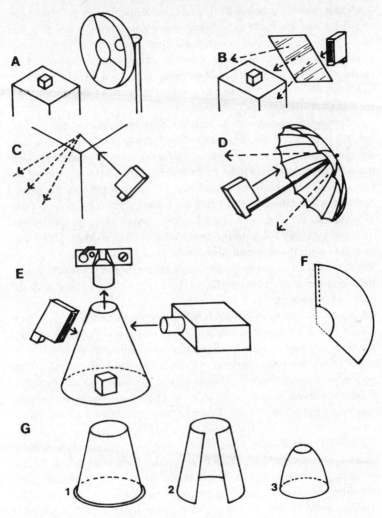

Diffuse lighting. Methods used to obtain soft, even lighting: A. Large light source with a shielded bulb. B. Large translucent diffuser. C. Bounce flash, e.g. from ceiling. D. Umbrella shaped flash reflector. E. Translucent cone with the peak removed; convenient and good light sources are flash or a slide projector. F. Cones can be made from tracing paper using the construction shown. G. Other forms of cone include: 1. Plastic drinking cup with the base removed; 2. Paper cone with a cutout for a mixture of direct and diffuse lighting; 3. Empty eggshell used as a cone.

flash tube in the bounce flash position. If this is not so, then the exposure will be incorrect. Many ingenious mechanical designs allow for this on units with integral sensors, so that the sensor sees straight ahead while the flash reflector is swivelled and turned as required. Undoubtedly the best solution is to have a remote sensor in a small separate unit to be mounted on the camera and connected by a lead to the flash gun it controls.

Another widely practised diffuse lighting technique is to use an umbrella shaped reflector, often called *brolly flash.* The reflector may be folded in the same manner as an umbrella for storage. The material of the reflector may be of plastic with a metallized gold or silver finish. Alternatively, white translucent plastic may be used, but this is less efficient. Reflector diameters vary from some 50 cm (20 inches) for use on a tripod with a small flash gun to some 180 cm (six feet) for large studio units. Hand-held units are available with the reflector supported on a shoulder brace.

While useful for most general subjects and some close-up work, the wide coverage is wasteful of light for extreme close-ups or macrophotography.

A very cheap ready-made alternative to a flash umbrella is to use a light source to transilluminate a large area of translucent material. An ideal material is the thin white perspex ceiling plate, about one metre (three feet) square, that is used for illuminated ceilings. The light source can be flash or tungsten and is positioned at a suitable distance behind the diffuser. A very effective simulation of soft window lighting is given. There is the inevitable loss of light, however.

Diffuse lighting is very effective for use with colour films which require a relatively low subject brightness range for good colour rendering. Some care must be taken that the reflecting surface does not alter the colour quality of the light source. Pink walls or blue ceilings impart a distinct colour cast when used as reflectors. The metallized silver brolly flash is an ideal reflecting medium.

The vast majority of subject material for close-up photography may be lit by diffuse lighting techniques. Subjects with reflecting surfaces are rendered better than by the alternative direct light method, but reflections of the source such as the brolly reflector can be very distracting.

For highly reflective subjects such as glass, coins, silverware and so on, completely uniform diffuse lighting is essential, nothing else will do. The requirement of completely uniform illumination of non-directional quality can only be achieved by means of some form of *light tent.*

A light tent can be literally a careful construction of tracing paper, muslin or linen arranged round the subject and lit from outside. A hole is left for the camera lens to view the subject. As expected a lot of light is wasted with this form of illumination.

There are a number of commercially made devices for this purpose usually in the form of large translucent perspex cones with the apex removed for the camera lens.

Fortunately, for the home studio and even for some location photography, a light tent arrangement can easily be fabricated from a roll of paper. The small size of most close-up subjects also means that other readily available items can be used as diffusers round the subject. A white plastic drinking cup with the base removed is one example. A carefully trimmed egg-shell and a white glass spherical light globe have been suggested as possibilities.

The subject can be positioned on a small stand of some sort inside the diffuser and a suitable background placed below this support. Illumination of the diffuser can be by means of a slide projector, flash or ordinary tungsten lighting.

Axial lighting

As described above, direct lighting is undiffused frontal lighting, usually necessitating some form of supplementary fill-in to lighten the cast shadows. In general the main light is well away from the lens-subject axis and the fill-in light near to this axis.

Axial lighting, as the name indicates, occurs when the light source is located on or very close to the optical axis. Small light sources are best. Thereby, uniform frontal lighting is given, very useful for some of the small subjects encountered in close-up work.

This type of lighting casts no visible shadows from the camera position and surface detail of the subject is seen only in terms of the amount of light reflected back to the camera. Reflectance depends

on the nature of the surfaces and their inclination to the camera axis.

By this means, subjects of very low surface relief such as worn coins, may be clearly shown when normal texture side-lighting would be unsatisfactory.

Another specific use of axial lighting is for the illumination of cavities, a cavity being an opening whose width is less than its depth. Examples include the inside of a cup or bowl, the human mouth and the inside of a flower.

Axial lighting may be too harsh for some subjects and changing to near axial lighting may provide the necessary degree of softening. True axial lighting is possible in a number of ways, most of them easily attained in the home studio with minimum resources.

The light source obviously cannot be positioned physically on the optical axis or it would obscure the subject from the camera. Instead, the light source is directed at 90 degrees to the optical axis from a position near the camera. A simple optical device called a *beamsplitter* is then placed in front of the camera lens inclined at 45 degrees to the optical axis. This beamsplitter then directs light at the subject by reflection from the source, while the camera can photograph the subject through it. The simplest form of beam-splitter is a thin flat piece of glass, the thinner the better to prevent deterioration of the image. Good examples are slide cover glasses made for microscopes and projectors.

Ordinary glass reflects about 5% of the incident light, this would be directed at the subject, the other 95% is transmitted and lost. This transmitted light could cause flare and unwanted illumination by local reflections, so some form of light trap is needed at the other side of the beamsplitter. A black velvet or flock paper lined box is an excellent light absorber.

Proper beamsplitters with higher reflectance: transmittance ratios are available commercially but at a considerable price. They can however be obtained sometimes quite cheaply as government surplus items. A beamsplitter with a 50% reflectance is called a *semi-silvered mirror*.

A suitable light source for use with a beamsplitter may be a small spot light or electronic flash or a slide projector.

Near axial lighting is easier to achieve than true axial lighting. The

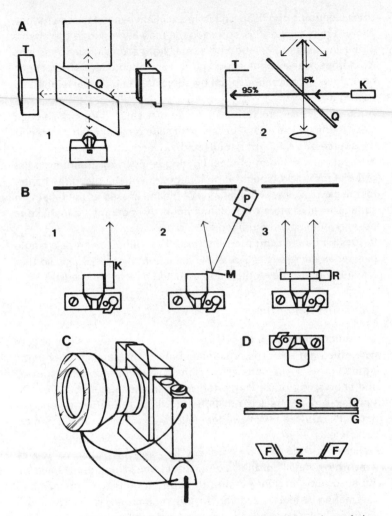

Axial lighting. A. True axial lighting is given by positioning a piece of glass Q to act as beamsplitter between the light source K and light trap T; 1. Typical arrangement Q is at 45° to the lens axis; 2. Plan view showing the ratios of reflected and transmitted light. B. Near axial lighting is easier to arrange: 1. Light source K close to the lens axis; 2. Small mirror M used with a spotlight P; 3. Ringflash R around lens. C. Typical amateur ringflash unit. D. A ringflash F used to give dark-field lighting with a transparent subject S arranged on an aperture in a black card Q on a sheet of glass G. Black card Z gives the black background.

small electronic ring flash unit is an excellent example of the former. The disadvantage of this source is the inability to judge the effects of the illumination. Positioning a small light source close to the lens is another near-axial method and is very often adopted for hand-held close-up macrophotography subjects using a small electronic flash gun.

Another device is to reflect light from a small mirror positioned close to the optical axis. A spotlight or slide projector can be used as the source and the light is deflected as needed by the mirror.

A less directional form of axial lighting is given by mounting a flat piece of metallic kitchen foil on to a board with a hole in the centre for the camera lens. The matt side of the foil is used as the reflecting surface to give more even illumination. A spotlight or suchlike is used to illuminate the reflector.

It goes without saying that a mirror reflex camera such as a single lens reflex camera is essential for axial lighting techniques so that the lighting may be studied and adjusted exactly as needed.

Transmitted lighting

Transmitted lighting or transillumination as it is often called, occurs when the light source is positioned behind the subject. Such back lighting gives a silhouette effect if the subject obscures the source, and shows fine detail if the subject is transparent or translucent. Another similar effect is rim lighting where the edges of opaque detail are outlined by a light source located to one side and behind the subject.

Transillumination is very suitable for subjects such as leaves which have details of their composition and structure revealed by the absorption of light passing through on its way to the camera. Fascinating studies are given to this technique, especially if the resulting negative is printed on to a hard grade of paper.

Transillumination may be achieved simply by positioning one light whether a flash unit, photoflood or the sun, to be behind the subject. Uneven illumination may result at times and an alternative method is to illuminate a white card or sheet of white translucent perspex behind the subject. This acts as a large diffuse source giving lowered contrast compared with the harsh direct light.

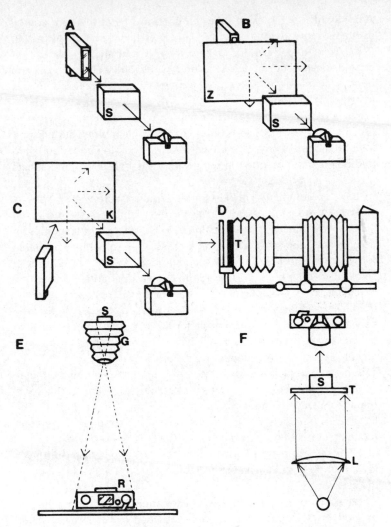

Transmitted lighting is often used with a translucent or transparent subject: A. Direct illumination from behind subject S. B. Diffuser behind the subject gives even illumination. C. White card K behind the subject can be illuminated from the front. D. A slide copying attachment uses a diffuser behind slide T and a bellows type lens hood. E. An enlarger G can be used to project an image onto film in a camera body R placed on the baseboard. F. Condenser type lens L can be used in conjunction with a specimen stage T on an extension bellows.

A constant problem with transillumination is that the light source is directed towards the lens and there is always a chance of getting flare. This may be reduced or removed entirely by the use of coated lenses and an efficient lens hood. The bellows type lens hood available as an accessory for many extension bellows units is ideal.

Transmitted light may be supplemented by frontal lighting so as to provide a three-dimensional effect of the subject when surface and internal detail are both shown. For example if a flower or dandelion puff ball is photographed into the sun, frontal fill-in lighting assists greatly.

In the case of many small subjects, when macrophotography is attempted, transmitted light may be the only possible means of illumination due to the difficulty of positioning light sources in front of the subject. A very useful accessory is sometimes available for the macrophotography of such subjects. It is in the form of a small platform which clips on to the bellows rail and is positioned parallel to the film plane. This *subject stage* or *stage plate,* is normally used with the camera pointing vertically down so that the subject may be rested on the platform. This is of interchangeable design and alternatives such as clear or coloured glass and translucent plastic may be clipped in position.

The clear glass allows direct transmission of light, which may be in the form of either a parallel or convergent beam. The latter is obtained using a condenser lens and a small light source. The lighting is extremely contrasty and very small changes of detail in the subject may be made visible.

The translucent plate provides diffuse transillumination and gives lower contrast so is less harsh in showing up marks or defects in the subject.

Another use of this last form of illumination is for the copying or duplication of colour transparencies. Instead of the subject stage, a device is used with convenient holders for mounted slides or rolls of uncut film. Extraneous light is excluded by a bellows type lens hood between the slide holder and lens.

A very simple means for macrophotography of suitable subjects using transillumination is provided by an enlarger. The subject is placed in the negative carrier and an exposure made at a suitable

magnification on to photographic paper or film as required. The camera (without its lens) can be used to record the image if placed on the enlarger baseboard. A reflex viewfinder of the waist-level type can be used to focus and frame the subject. Exposure is by means of the camera shutter with the enlarger lamp on.

Dark-field lighting

Some subjects may require a particular variation of the transmitted light technique when a dark background or field is needed. The usual transillumination method shows the subject as density and colour variations against a bright background. Often fine detail is lost against this background. The dark field technique greatly heightens contrast and picks out edge details, such as fine hairs around the subject; and can be combined with carefully balanced front lighting to show surface detail.

The essence of the dark-field technique is to provide a truly black background some suitable distance behind the subject. This background can be a piece of black card, or ideally, black velvet. The subject is illuminated obliquely from the rear with the light or lights situated just outside the background area. The multiple refraction and scattering by the fully or partially transparent subject renders its detail visible against a black field.

One possible arrangement is to place the subject on a glass plate surrounded by a black card baffle. A ring flash unit is placed below the subject so that its direct rays are blocked from the camera by the card baffle. A black background is placed in the centre of the ring flash below the subject. In the absence of a ring flash unit, a single light or pair of lights can be used, or a small spotlight can be directed onto a small mirror beside the background.

Dark field lighting is a rather tricky form of lighting but with the right subject and a certain amount of trial and error it is capable of giving superb effects.

Window light

The size of window light is large with respect to the subject and so the lighting on the side facing the window is even and diffuse. The

119

shadows on the other side may be anything from dark to fairly light depending on the reflection characteristics of the room. Suitable reflectors may be needed to reduce subject brightness range.

The lighting level falls off rapidly as the distance from the window decreases, and the colour quality of the light depends on the direction of the window with respect to north. For colour photography by window light, it may be necessary to employ light balancing filters to remove possible blue colour casts due to north facing windows.

The natural characteristics of window light are very popular and many photographic light sources are devised to try and simulate such lighting.

Copy lighting

At first consideration it would seem that the lighting needed to copy a flat original, such as a drawing or the page of a book, is a simple matter. In fact it is not easy to arrange lighting so as to subdue surface texture from a heavy paper or reflections from inks and the like, while also eliminating shadows and giving even illumination over the whole surface.

The simplest arrangement to achieve copy lighting is to have two lights of identical properties and output equidistant from the subject to give a large, evenly illuminated area into which the subject is placed. This is normally achieved by placing the lights at the same height from the floor as the camera, and with their axes at 45 degrees to the subject. This means any surface reflections are directed away from the camera.

The subject must be held flat to avoid reflections. Also it must be perpendicular to the lens axis to ensure that the image is not distorted.

An even better arrangement of copy lighting is to have four lights of similar power and properties positioned at the corners of a square or rectangle, pointing inwards at the subject area at angles of 45 degrees. Some enlargers have available such copy lights as an accessory.

A very reasonable alternative to four lights, and better than two flood lights, is to use two long linear light sources in suitable

reflectors. Fluorescent light sources are useful for this purpose but are not suitable for use with colour film.

The evenness of the copy lighting may be checked by a light meter using close-up readings from a white card placed in the subject area. The corner and peripheral readings are compared with the central value.

Backgrounds

The general aims are to achieve a background that does not detract from the subject but only serves to enhance it. Sharp in-focus detail in the background should be avoided wherever possible. This is particularly noticeable with highlight detail, and is true whether it is sharp or out of focus.

Another common source of unwelcome background detail is multiple shadows or deep, unrelieved tonal masses. Unless the photographer is a master of lighting and composition, such tonal masses are best avoided.

For black and white photography, backgrounds are black, white, grey or natural. Natural backgrounds occur when the environment of the subject is to be shown or hinted at, for example flowers in a field or in a wood.

An isolating background is for instance a curved sheet of paper which can be positioned behind a flower, leaf or stone so as to give a uniform background tone as a deliberate choice. Such an approach is necessary in the home studio.

A black background is eminently suitable for many subjects and types of lighting. Its density of tone masks or obscures shadow shapes, sizes or the number of shadows which could otherwise prove objectionable on a white or grey background. Good visual contrast is given to the subject and lens flare is considerably less than from a white background.

Methods of obtaining a black background are numerous. Sheer absence of light on the region may be adequate. The rapid fall-off of illumination from an electronic flash gun often achieves this end, especially if used for side lighting. Even a white card background, if lit inadequately, may be rendered as black.

Where illumination is strong as a result of the main lighting on the

subject, then black card, black flock paper or black cloth may be needed. Such materials, however, do have some surface sheen and reflections. Best of all, although much more expensive, is black velvet. Often suitable pieces can be obtained in jumble sales in the form of clothing or curtains which may only need cleaning and dying black.

Few subjects need a grey background and will often appear improved by being photographed against black or white. Grey backgrounds are obtained by using background material of the tone required or by under-lighting a white background.

A white card or piece of material, *suitably lit* gives a white background. Avoidance of subject shadows from the main light is essential, although these may be lightened by a fill-in light. Ideally, a separate light is needed for the background. The trio of main, fill and background lights forms the basic system of most lighting schemes.

One problem which may occur with backgrounds is a long shadow or a tone difference where background and subject meet. The ideal arrangement is a continuous background such as a piece of card or paper curved behind and below the subject, giving no distinct demarcation between the two. The subject may be raised up from the background material on various concealed supports, to help with placement of shadows.

Domestic kitchen foil, if unwrinkled and with the matt side to the subject, gives a white background when lit by a different lighting source.

A versatile method of producing a white background, especially for arrays of small objects or individual subjects, is to place the object on a light box or have it on a sheet of glass above the box. The subject is then lit as appropriate, and the cast shadows disappear on the white luminous background.

Ideally, such a light box should have variable intensity illumination to allow low intensity for setting up, and thus avoid any damage to the subject. High intensity is then selected for the exposure. If excessive intensity is used then this may cause flare in the camera and reduce the contrast of the results. If the light intensity cannot be varied then a double exposure technique can be used for static subjects. The first exposure is with the subject's frontal lighting on

and the light box illuminator turned off. The second exposure is with the main lights off and the illuminator turned on. Both these exposures should be made with the room light off. The ratio of the two exposures gives the required results.

Such a light box may be constructed using opal perspex and plywood. Linear fluorescent lamps are ideal light sources because these do not get hot but are not easily dimmed and are unsuitable for use with colour film. Linear tungsten lamps are preferable for colour work.

For macrophotography opal diffusers are available as bases to the small subject stages which can be attached as accessories to some extension bellows. These diffusers are illuminated to give a white background. The use of colour filters below the stage gives the possibility of coloured backgrounds.

For general photography, coloured backgrounds may be made from suitable lengths of colour paper or material. Care is needed in the choice of colour for the background as it may influence the apparent colour of the subject. This phenomenon is known as *simultaneous colour contrast* and is one of the reasons why certain colours of background seem best suited to subjects of specific colours. For instance red subjects are enhanced by a green background.

Reflections and their control

Subject reflections are the images of the surrounds and particularly the light sources used to illuminate the subject. Of all the phenomena encountered in photography, reflections in the subject or surrounds can be the most exasperating and difficult to control. Conversely, when it is possible to control and manipulate reflections they offer a powerful means of delineating subject texture, surface finish and shape.

Curiously enough, a subject devoid of reflections has a dull, lifeless appearance, a common example being the presence or absence of the catchlights in a person's eyes. A portrait without this 'twinkle' often appears lifeless.

A rough, matt or non-smooth surface gives *diffuse* reflections of low or irregular intensity compared with the source and may appear

roughly the same over a wide viewing angle. White paper is a good example of diffuse reflection.

Conversely, shiny smooth or polished surfaces give an intense *specular* reflection of a light source or a distorted picture of a surround. Metal, glass and glazed surfaces are examples.

The most obvious means of controlling reflections is to reposition the light source(s). This is provided that the desired lighting is still possible after this alteration, of course.

Sometimes the light source reflection or images of the surround are deliberately left in to show the nature of the surface. This often is the case with glassware. A useful device is to place pieces of black or white card outside the area of the subject seen by the lens, so as to give reflections at the edges of light or dark shiny objects respectively. For example, transparent glassware on a white background can be improved by reflections from carefully positoned black card.

Spherical objects are easily shown as such by a ring of card around them. In all such cases, it is essential to be able to observe the exact nature of the reflections in the viewfinder.

One technique of removing all unwanted reflections in shiny metal objects is to surround them with a light tent so that reflection is uniform and featureless.

A method sometimes useful for the small subjects is to immerse them completely in water so that irregular surfaces are smoothed out by the water medium.

Yet another technique which depends upon the surface properties of the subject is to use *polarizing filters* in various ways.

The predominantly diffuse reflections from subjects made of non-metallic materials, with the exceptions of materials such as polished glass, consist of light which is partially plane polarized. If a polarizing filter is rotated in front of the camera lens a position may be found which blocks the plane polarized light from the reflection, causing it to be diminished or even vanish altogether. Such an effect requires a particular viewpoint for the camera.

For some subjects, such as the copying of oil paintings, it is essential to be able to control reflections from surface detail. The light sources, usually four in the ideal copying positions, may be fitted with large polarizing filters. These may be rotated individually

and when used with a polarizing filter over the lens, reflections can be controlled. Retention of some reflections is essential to show surface texture as complete removal gives a dead, flat appearance. As a bonus, subject colours may also be increased in saturation by use of polarizing filters.

The specular reflections of metal objects can be controlled in a similar way by using a polarizing filter over the light source. The camera polarizing filter controls the amount of reflection.

Alternative techniques for metals, apart from a light tent, are by spraying the surface with a dulling fluid or by patting all over with a moist material such as putty. These are time-consuming techniques which may also harm the subject.

As already mentioned, one of the major objections to the use of small electronic flash units is the absence of modelling lights and there can be no judgement of the position and intensity of unwanted reflections.

A final word

Never forego the opportunity of taking a close-up picture of a subject just because you do not have a particular item of equipment or the ideal film in your camera. Photograph as best you can in the circumstances for it may be an unrepeatable subject. Using the ability you already have may give a better result than a new piece of apparatus that you are using for the first time. Remember it is better to have an acceptable record than no result at all, even if you are sure that optimum results would have been given if only . . . !

Exposure Techniques

Exposure measurement

For most photography the camera exposure is determined from one light measurement—that of light reflected from the subject, or alternatively, the light incident on the subject. Then, dependent on the film speed, a suitable combination of aperture and shutter speed is chosen. This choice depends on the depth of field required, and the necessary exposure time to stop subject motion or to allow the camera to be hand held and so on.

Exposure corrections may need to be applied for the use of filters or other optical attachments. Also the subject itself may warrant alteration to exposure for deliberate effects, for example to give a silhouette. Finally, correction may be needed for close-up photography, depending upon the magnification and equipment in use.

Close-up photography can also pose problems of exactly how or where to take exposure meter readings and then how exactly to apply corrections. These and other considerations are worth examining in detail, for it is most frustrating to have spent considerable time and effort in locating, framing and focusing on a subject, only to find that the results are incorrectly exposed. For difficult subjects, it is best to 'bracket' exposures.

The exposure meter

The exposure meter is a device for measuring the light falling on or reflected from the subject. Strictly speaking, it is correctly termed a *light meter*. When its reading is used in conjunction with built-in calculator dials or suitable electronic circuitry, it will indicate suitable combinations of *f*-number and exposure time for a particular film speed.

Alternatively, when it is incorporated into a camera, it may indicate

a specific aperture or shutter speed or even set that value auto-
matically.

Methods of using an exposure meter

The use of an exposure meter in an uninformed manner will in no
way guarantee correctly exposed results. A little knowledge of how
the meter is calibrated, together with the appropriate metering
technique, will greatly improve the proportion of excellent results.
There are of course certain instances where only prior experience
can be of use, such as with fluorescent or phosphorescent subjects
or in moonlight. Sometimes the only way to guarantee an accept-
able result is to bracket exposures over a range of exposure times
or aperture stops. Such occasions are infrequent however.

The variations of tone and colour of the image are collected by the
photocell, and are integrated to give a total response. This gives an
integrated reading for the subject.

The meter is calibrated in such a manner that when it measures the
reflected light from an *average subject,* or alternatively the light
incident on as assumed average subject, the calculator dials and
controls indicates a correct exposure level for the film in use. In
most cases this approach to exposure level will give an acceptable
result.

The average subject

An average subject for the purposes of exposure meter readings
is assumed to be one which reflects back to the camera only 18%
of the light incident upon it. This subject can be represented by
devices such as the Kodak Neutral Test Card, whose reflectance is
some 18%. The neutral mid-grey colour of the card indicates that
the average scene also has a distribution of tone and colour which
integrates to this appearance. This card can be used for a number
of exposure measurement techniques.

A significant proportion of subjects are, of course, not average.
A small bright tone in a large, dark field, is 'seen' by the light meter
as an average scene and will produce an over-exposed result.
Conversely, a dark subject with a light background will produce an

under-exposed result. Experience of these kinds of subjects will help the photographer to apply the appropriate corrections to the indicated exposures. Many cameras have built-in correction, which is operated by some dial or switch. This correction procedure applies to incident and reflected light readings.

Spot readings

The obvious alternative to an integrated reading is a spot or small area meter reading from a selected part of the subject. This can be achieved by taking a meter very close to the subject and taking a reflected light measurement from a chosen region.

Usually, the spot reading is made with a meter that has a small acceptance angle, necessitating also some form of viewfinder or aiming device. Some cameras offer a choice of integrated or spot readings as part of their metering system.

The spot reading can be very convenient, but it must be remembered that the metering system again assumes that this small region will integrate to an average scene of some 18% reflectance. This means that great care must be taken in selecting the area to be measured. While of doubtful value for inexperienced users, the spot measurement technique can be of great assistance for many close-up subjects.

Weighted readings

A third variety of light measurement, which gives an excellent compromize between integrated and spot readings, is that of taking a *weighted reading*.

This method is confined to SLR cameras with through-the-lens metering systems and generally uses two or more photocells to measure different areas or parts of the scene. When the photocell outputs are combined to give an indication of exposure, emphasis is on the central or lower central region of the scene framed in the viewfinder. This is because the important part of the subject is usually situated in this region and should dominate the exposure calculations. The remainder of the subject, often a bright sky, is of lesser importance and should not strongly influence measurements.

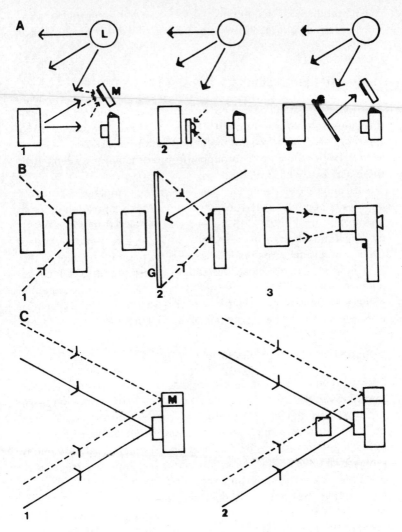

Exposure measurement. A. Separate hand exposure meter to measure:
1. Light from source L reflected by the subject; 2. Incident light; 3. From a keytone or grey card. B1. Readings may be in error due to the small size of the subject; 2. Grey card technique can be used; 3. Narrow angle spot meter is another solution. C1. A meter on the camera has a similar acceptance angle to the lens for distant subjects; 2. Such meters are prone to parallax errors for close-up subjects.

The method enjoys a high rate of success, but if no corrections are applied to the light readings, certain types of subject can give poor results.

Reflected light readings

The exposure meter is aimed at the subject and the photocell measures light reflected from it. This is the classic method of using the hand held meter or spot meter and also the only form possible with a camera having a through-the-lens metering system. It is the most widely used method.

The selenium cell meter with an acceptance angle of about 50 degrees is pointed at the subject from the camera position in most instances. Small angle CdS meters may be aimed more precisely by a viewfinder system in the meter or by using a camera viewfinder. Greater precision in the reading is given by taking the meter to the subject, and taking a close-up reading of the region of critical or greatest interest. This is often the case in close-up photography when the subject may be smaller even than the photocell area. A true spot meter can be a great help in such instances.

Substitution techniques (key-tone)

A useful type of reflected light reading is to take a meter reading not from the subject itself, which may be difficult for various reasons, but from an artificial or substitute subject. Such a *key-tone* may be a grey card of some 18% reflectance. Often this card has 90% reflectance white on its reverse side and if there is very little light it may give a useful deflection of the meter needle compared with the grey side. The exposure indicated is then multiplied by a factor of five, being the ratio of reflectance between the white and grey sides. Often a clean piece of white paper may be used as a key-tone for the meter reading.

Many standardized copying set-ups use this white card method to check on the even-ness and quantity of the lighting as well as to determine exposure.

The substitution method is often very useful for close-up photography especially when the subject is very small. Care must be

taken to see that the shadow of a hand-held meter does not fall on the card and falsify results.

The substitution technique is also very useful when the subject cannot be approached, either due to obstructions or for fear of disturbance.

Incident light readings

As an alternative to measuring the light reflected from the subject, the intensity of the illumination on the subject may be measured, termed an *incident light reading.* As the subject may be lit by one or a number of sources from various directions, a simple reading from a meter with a photocell of flat construction could be misleading. There is also the problem of which direction to point the meter. The answer is to use a light diffuser over the photocell, which may take the form of a flat, hemispherical or complex shaped attachment of translucent plastic. This attachment collects light from about a 180° arc. To take a light reading the meter is then pointed towards the camera from the subject position.

The assumption on which the indicated exposure is based is that the subject is of average reflectance and tonal distribution. An exposure correction must be applied to non-average subjects. For instance, a dark toned subject must be given perhaps double or more the indicated exposure.

Incident light readings are limited to hand meters of large acceptance area and are used exclusively in exposure meters designed for electronic flash work.

For many close-up subjects this form of metering is ideal because the light reading may be taken without disturbing either the subject or the lighting.

Trials and tabulation

It is always a good idea to record all relevant exposure data, particularly if the subject is unique or difficult to light, and so on. When a series of photographs are to be made of similar subjects, it is wise to run tests first, and using the recorded data and test results, complete the series later.

Non through-the-lens camera meters

Because the meter window is not seeing exactly the same scene as the viewfinder window when taking close-up photographs, the results may be incorrectly exposed. For example the lens may be taking a close-up of flowers on a cliff top but the meter reading is taken from the sea surface or sky.

Obviously, the meter can be pointed at the subject, a reading taken and the camera lens then pointed back at the subject. Substitution techniques may also be used.

The *fully automatic meter* is now common in many cameras and the output from the photocell is used to set the shutter speed or the aperture stop, and thereby give correct exposure for average subjects in general photography. This type can be a liability in applications of close-up work where exposure correction is needed. One answer is to disconnect the metering system and use the camera in its manual mode.

Through-the-lens metering

The advent of ultra-sensitive small CdS photocells, and more recently silicon photodiodes, enable in-camera exposure metering to be very reliable and accurate. Thereby, most subjects can be metered, including the use of extension tubes and bellows, attachment to a microscope and so on, as well as routine situations. The through-the-lens meter gives a reflected light reading of the subject and may be fully integrated over the whole scene, or a small area (including spot) reading of the scene shown in the viewfinder.

The sensitivity of most TTL metering systems is adequate for most close-up situations, especially when full aperture metering is possible.

Full aperture metering

Irrespective of the form of TTL metering in the camera, the greater the amount of light entering the lens the more accurate the measurement is likely to be. Readings taken at the limit of sensitivity

of the photocell may be inaccurate. Therefore full aperture metering is an advantage.

A further convenience of full aperture metering is that the lens is normally at full aperture to facilitate focusing on a bright screen in the viewfinder, only stopping down to the selected aperture just prior to exposure. Stopping down the lens to the selected aperture to take an exposure reading is inconvenient. Most cameras with full exposure automation have *aperture preferred* systems where the metering system selects the exposure time after the aperture has been chosen manually. A less common arrangement is the *shutter speed preferred* system where the shutter speed is set by the user and the lens aperture is then set just before exposure by the metering system.

Unfortunately, full aperture metering for close-up photography is not always possible because the necessary linkages to the camera body may be lost or disconnected when extension tubes or bellows are used. The system may then revert to the stop-down metering system. Shutter speed preferred systems in particular cause complications in that only special extension tubes and bellows can be used with them or all automation may be lost.

One of the great advantages of the simple close-up lens is that no camera functions are impaired. No exposure corrections are necessary either.

Stop-down metering

The alternative form of through-the-lens metering, termed stop-down metering, requires that the lens is progressively stopped down to the exposure setting needed. Consequently the viewfinder image dims as this is done and sensitivity of metering is lost. When some simple types of extension tubes and bellows are used, even with full aperture metering systems, then the exposure is determined at the stop-down aperture. This is usually an inconvenient way of working, since at the small apertures common in close-up work, plus any moderate amount of extension, the viewfinder image will be dim and the light reaching the photocell may be inadequate to give a useful meter reading.

One way of overcoming this is to take the meter reading at a large

aperture and then mentally calculate the corresponding exposure time setting at the required smaller aperture. Automatic cameras may not easily be used in this way unless manual over-ride is selected.

Fortunately, at some greater expense, it is possible to buy extension devices which offer fully automatic iris operation and full aperture metering. The money spent is more than offset by the convenience of operation.

Also stop-down metering is necessary when other lenses, such as enlarger lenses, are used. These lenses often have a click stop diaphragm.

Exposure for close-ups

There are many factors that influence how a close-up photograph is taken. One factor is the desired perspective rendering of the subject, which dictates a certain taking distance. The necessary magnification then decides the ideal focal length of lens to use. The subject may need a certain aperture to achieve sufficient depth of field, and may also be moving which means a certain minimum shutter speed. Also the camera may be hand held. All these factors obviously affect the choice of shutter speed and aperture, which also depends on lighting and film speed. The final choice is what makes photography a creative and individual art form.

Exposure corrections

In the absence of through-the-lens metering, or in a situation where it cannot be used such as with flash, manual corrections may be necessary to the exposure setting. One obvious correction is when the subject is not average as defined on page 127.

When some filters are used over the camera lens then an increase in exposure is necessary. With the exception of near colourless UV or skylight filters, every colour filter absorbs some visible light. For example, a yellow filter absorbs blue light. All filters are given an exposure correction factor known as a *filter factor,* which depends on the filter, the lighting, and the film used. To determine the corrected exposure you simply multiply the indicated exposure by the filter factor.

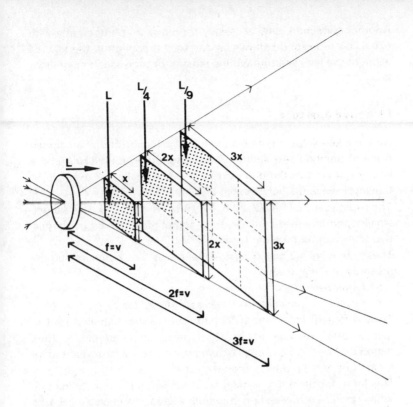

LENS EXTENSION (v)	MAGNIFICATION	RELATIVE IMAGE AREA COVERED	RELATIVE ILLUMINATION ON FILM	EFFECTIVE f-NUMBER (LENS AT f/4)	f-NUMBER CORRECTION FACTOR	EXPOSURE TIME CORRECTION FACTOR
f	~	1	1	f/4	1	1
2f	1	4	$\frac{1}{4}$	f/8	2	4
3f	2	9	$\frac{1}{9}$	f/12	3	9
4f	3	16	$\frac{1}{16}$	f/16	4	16

Exposure corrections for close-ups. As the lens is progressively extended further away from the film plane to focus on near subjects, the amount of light L transmitted by the lens (as determined by the f-number set) stays constant, but the image area increases as shown. Consequently, corrections must be made to the calculated exposure settings; examples are shown in the table.

Another correction, only necessary for close-up photography with extension tubes and bellows, is due to the change in the marked value of the lens aperture with extension or increase in magnification.

Effective aperture

Each marked value on the iris control of a lens is one of an agreed scale of numbers. An aperture transmits either double or half the amount of light as the one next to it in the scale. For example $f4$ transmits twice the light of $f5.6$ and half that of $f2.8$.

The usual scale is $f1.4$, $f2$, $f2.8$, $f4$, $f5.6$, $f8$, $f11$, $f16$, $f22$. Larger, smaller and intermediate values are sometimes marked or alternative scales found on older lenses.

These numbers are called *relative apertures* or *f-numbers* and are given by the relationship

$$f\text{-number} = \frac{\text{focal length of lens}}{\text{diameter of clear aperture of lens}}$$

Thus, a lens of focal length 50 mm with its iris diaphragm set to give a clear aperture of 12.5 mm gives an f-number of four, denoted $f4$ or $f/4$. So a small f-number indicates a large aperture or great light passing power and vice versa.

This form of calibration and definition of f-number only holds true when the lens is focused on infinity or a great distance. As the lens is progressively moved away from the film when it is focused on closer and closer distances, the amount of light reaching the film is reduced.

This is a consequence of a physical law termed the Inverse Square Law of Illumination which shows that as a light source, in this case the iris of a given diameter passing light, is moved to twice its distance from a given plane, such as the film plane, then the illummination on the plane is reduced to one quarter ($1/2^2$) of its previous value. Increasing the distance by a factor of three reduces the illumination to one ninth ($1/3^2$) of its former value and so on.

So, when a lens is sufficiently extended from the camera to give a magnification of one on the film, i.e. life size, it will be two focal lengths distance from the film. Thus the illumination on the film will be reduced to one quarter of the value from the same subject

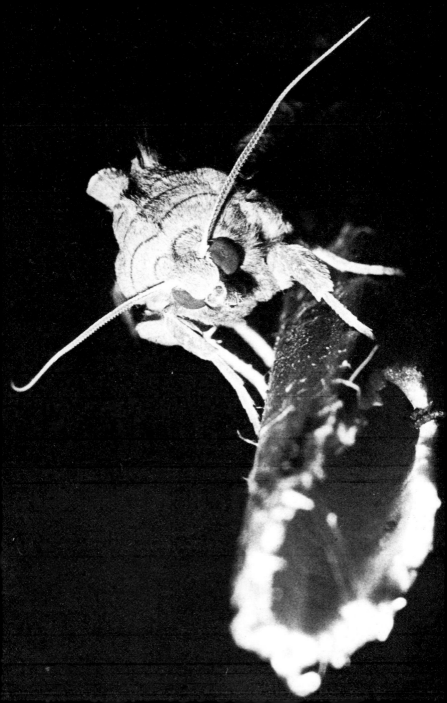

Above: It was essential, because of limited depth of field, to focus carefully on the eye. This grass snake was photographed with a Leica camera using a reflex housing and a 90mm lens – *Sidney Ray.*

Page 139: The texture of peeling paint is a favourite abstract subject. The lighting is diffuse sunshine, and a no. 1 close-up lens was used on a 6 x 6 cm TLR camera; aperture was *f*22 – *Sidney Ray.*

Page 138: An attractive close-up study of frost on leaves taken with a Leica rangefinder camera and a 90mm lens. The exposure was 1/250 sec. at *f*8 – *Neville Newman.*

Page 137: A moth photographed at night using a 35mm SLR camera and electronic flash. Life-size magnification was obtained on the negative by using a bellows unit – *Sidney Ray.*

Above: Close-ups of shy subjects are best obtained by using a long focus lens, together with a weak close-up lens or short extension tube. The latter technique is used here with a 180mm lens on a 6 x 6 cm TLR camera — *Sidney Ray.*

Page 142: This small wooden figure at the end of a church pew was photographed, using a 6 x 6 cm TLR camera on a tripod, by natural light. Exposure was 60 seconds at *f*16 — *Sidney Ray.*

Page 143: A low viewpoint helps to give emphasis to the child and is easily achieved with a reflex camera. The main flash unit is positioned to the right of the camera and a small unit is used on the camera as a fill-in light — *Sidney Ray.*

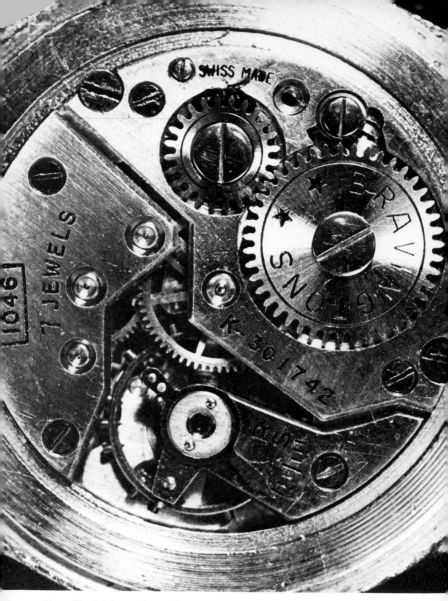

Above: The lighting used was direct and near axial to show up the surface textures of the watch components. A 50mm lens plus extension tubes was used on a Leica camera; same-size reproduction on the negative — *Sidney Ray.*

when it is at a distance. In other words, the set f-number on the iris control ring will have an effective value of an f-number two stops less in value i.e. a set value of $f4$ will be effectively $f8$.

This *effective aperture* must always be used in exposure calculations. Of course, cameras using through-the-lens metering automatically correct for this loss of light as calculations are based on the amount of light at the film plane or its equivalent.

The value of the effective aperture of the lens, as distinct from the relative aperture, may easily be calculated from the relationship:

$$\text{effective aperture or } f\text{-number} = \frac{\text{lens to film distance}}{\text{diameter of clear aperture of lens}}$$

So, in the example previously used, for a 50 mm lens used at a magnification of 1.0, the lens extension is two focal lengths or 100 mm, so that the aperture diameter of 12.5 mm now gives an effective aperture of $f8$ instead of a relative aperture of $f4$.

Fortunately it is very easy to work out the effective aperture of a lens at any set relative aperture provided that the image magnification is known.

If we denote the relative aperture by N, the effective aperture by N_e and magnification by m then it can be shown that

$$N_e = N (1 + m)$$

So, that at a magnification of two, a set f-number of $f8$ becomes an effective aperture of $f22$, to the nearest marked value.

Again, if a working aperture or effective aperture of $f8$ is needed as dictated by the considerations above, then a value of $f2.8$ must be set on the lens.

It can be seen that large magnifications, as used in macro-photography, give very small effective apertures.

Another formula to give effective aperture, based upon the two definitions of relative and effective apertures can often be useful as well.

$$N_e = N \times \frac{\text{bellows extension}}{\text{focal length of lens}}$$

When extension bellows are used, a scale in millimetres may be provided or a ruler can be used to measure extension and the necessary exposure correction made.

Corrections to exposure time

It is of course possible to alter exposure time to compensate for the effective aperture instead of having to alter the iris diaphragm by the appropriate number of aperture settings. Often a change in exposure time is a much easier correction to carry out, especially if the subject is static and long exposure times can be given.

It is also a valuable method if a specific working aperture is dictated by lens performance, available aperture of the lens or by depth of field requirements.

Once again a simple equation may be used to calculate the corrected exposure time T, from the indicated exposure time t, according to the image magnification m. The relationship is:

$$T = t\,(1 + m)^2$$

For instance, if when working at a magnification of 0.5, or half life size, an exposure meter reading indicated uncorrected exposure settings of 1/15 second at desired f-number of $f22$, the correct exposure time would be $1/15 \times (1 + 0.5)^2$ or 1/8 second at $f22$ as set, to the nearest marked shutter speed.

Tables of correction factors are given in the data section.

It is also possible to calculate exposure correction factors from the bellows extension, using the relationship

$$T = t \times \left(\frac{\text{bellows extension}}{\text{focal length of lens}}\right)^2$$

So that a 50 mm lens used with a bellows extension of 100 mm, i.e. at unit magnification, needs an exposure time correction factor of $\left(\dfrac{100}{50}\right)^2$ or 4.

Correction factors on equipment

In some instances it is not easy or convenient to work out the necessary exposure corrections for magnification or for bellows extension.

If magnification can be determined such as from the size of the subject and its image size on the film, then calculations are possible such as with the aid of a simple pocket calculator. Alternatively, tables of correction factors can be consulted.

To assist in the assessment of image size on the film, some view-finders have engraved marks a known distance apart. Of great help are screens with grids available as an accessory or alternative for many reflex cameras.

Most macro lenses have engraved on their focusing mount the image scale or magnification together with the necessary exposure correction factor. Such lenses usually focus from infinity to half life size and then with the aid of a special extension tube, from half to full life size. There are normally two engraved scales to give magnification and correction factors. To avoid confusion subject distances below about 0.3 m (one foot) are not usually indicated.

Extension tubes may also be engraved with individual exposure correction factors, which are combined when more than one tube is used. Usually a set of three or four such rings or tubes are provided by a manufacturer for a particular camera. When used with a standard lens they normally give enough extension to give life size reproduction on the film. Their combined exposure correction factors will then total ×4 or plus two aperture stops.

Extension bellows units allow continuous variation in lens to film distance and hence in magnification, depending on the focal length of the lens in use. This typically reaches a magnification of two with a standard lens. Most bellows units indicate the extension in millimetres on an engraved scale, and this is often combined with exposure correction factors for a particular lens or lenses. This arrangement is a great convenience, especially when a known magnification is pre-set and the lens securely clamped in place on the rails. Focusing is then achieved most conveniently by moving the whole assembly on a focusing rail.

In the absence of such scales or TTL metering or if magnification cannot conveniently be estimated, then measuring the lens extension will give the exposure correction (see page 145).

Unfortunately, the lenses for miniature cameras are usually long in length as compared with their focal length. This poses the problem of which part of the lens to measure from to decide extension from the film plane.

The one situation where this method can be applied is for large format cameras, where the bellows extension is considerable and lenses are of short physical length compared with focal length.

Image dimensions on the ground glass screen are also easily measured for the exact calculation of magnification.

Exposure with close-up lenses

The useful features of a close-up lens or supplementary lens for general out and about close-up photography have been discussed, but it is useful to repeat them again. Principally they are inexpensive, small, and convenient to use with no loss of automation. Their main disadvantage is poor quality at wide apertures.

Also close-up lenses *require no such exposure corrections.* All that must be remembered is to choose an *f*-number that gives acceptable optical performance. For a standard lens this is likely to be about *f*8.

The reason why no exposure correction is necessary is that the combination of the camera lens and the supplementary lens gives in effect another lens system of different focal length. With a positive supplementary lens the combined focal length is in fact shorter than the camera lens alone. For example, the combination of a 50 mm focal length camera lens with a +3 dioptre close-up lens gives a new focal length of 43.5 mm.

With the camera lens aperture set at *f*11, the effective diameter of the iris would be approximately 4.55 mm. This physical opening is unchanged for the new reduced focal length and the effective aperture is therefore 43.5 divided by 4.55 giving *f*9.6. In other words the combination is working at approximately one half stop more than the set value on the aperture scale.

With the camera lens focused on infinity, the addition of the +3 supplementary lens gives a sharp image whose magnification is approximately 0.15. This, according to the formula on page 146 would necessitate an increase in indicated exposure time by a factor of 1.32, or an increase of one third stop. But the combined lens system has an effective aperture of *f*9.6 (*f*11 is set on the lens), so the exposure compensation is already allowed for. This means the user just sets the exposure time and *f*-number indicated by the exposure meter.

The ease and speed of use of a close-up lens means that many good pictures can be 'grabbed' long before an extension tube or

bellows unit is taken out of the gadget bag. Their convenience often outweighs a slight quality loss.

Even more useful as a tool for instant switching from distant subjects to close-ups is the macro lens, but exposure corrections are still needed unless TTL metering is used. One special type of lens which is very useful is the zoom lens with a close-focusing or macro mode of operation.

Macro-focusing zoom lenses

This type of lens has moving groups of elements which provide a close focusing range, often to half life size, and help produce a very useful versatile lens.

No change in the set exposure for more distant exposures is needed when the focus is changed to close-up. This is because the changes in the positions of the moving groups of elements in front of the iris diaphragm are such that while focal length is changed, relative aperture remains constant.

A normal feature of a zoom lens is that when focused on a given subject, the focal length can be changed without altering focus. In the close focusing mode this is no longer so and the lens can only focus at close distances as the focal length is reduced.

Electronic flash exposures

To obtain correct exposure with flash requires that you only select the necessary lens aperture. The exposure time is relatively unimportant provided that the camera shutter speed selected is suitable for correct synchronization with the flash unit. The only exception to this is when electronic flash is mixed with daylight to give synchro-daylight. The exposure duration of the flash is very short, usually one thousandth of a second or less, especially in automatic or computer flash units.

The light output of a flash gun may also be considered as constant for a given set of circumstances provided that sufficient charging time has been allowed.

It is also relatively easy to select an aperture that will give the necessary depth of field or where lens performance is optimum and

so on. Also, subject movements and image blur are no longer sources of poor quality results. There are a number of ways of obtaining correct exposure with flash units and these are described in some detail below.

Guide numbers

Given that flash light output is constant, for an average subject the only exposure variables are the distance from the flash to the subject, the speed of the film in the camera and the necessary f-number to give correct exposure.

The f-number necessary for a given film speed can be calculated from the guide number. These values are provided by the flash manufacturer or determined experimentally by the photographer. Different film speeds give different guide numbers.

A guide number G is the product of the relative aperture N and the flash to subject distance D, so that G = ND. Guide numbers for both metres and feet are quoted.

The f-number is therefore found by dividing the guide number by the subject distance, which is read from the lens focusing scale or measured with a ruler or a tape.

For example, if the guide number is 33 (metre) or 110 (feet) for 125 ASA film, a subject distance of three metres (ten feet) needs an aperture of f11.

These guide numbers are usable down to subject distances of about one metre (three feet). Thereafter, some adjustment may be needed, determined by practical tests. This is because the nearness of the flash to the subject can cause a loss of efficiency, due to the design of the integral reflector of the flash. The reflector being designed for maximum efficiency at greater distances.

Calculator dials

The majority of flash guns have, as part of their outer construction, some form of calculator dial which automatically performs the guide number calculations.

The procedure is to set the film speed against an index mark, and at a glance the aperture required for a given subject distance is easily found.

Unfortunately such dials seldom, if ever, show the necessary f-number for distances less than one metre (three feet). So either individual tests are needed, or the f-number must be calculated from the guide number (see above).

Of course, for close-up photography at large magnifications the indicated f-number must be altered in accordance with allowances for effective aperture.

Variable flash output

Many electronic flash units offer an option of full or reduced power by simple manual switching arrangements. Such a feature is useful on a number of occasions, such as when the flash is relatively close to the subject and the camera is loaded with fast film. The reduced power avoids over-exposure even when the lens is fully stopped down. The usual reduction for the more powerful flashguns is to one quarter of full output.

Of course, an obvious method of avoiding over-exposure is to move the flash head further away from the subject. Another approach, when it is not possible to reduce flash output, is to put a diffuser over the flash tube. As a rule of thumb, one thickness of clean white handkerchief or tissue is usually reckoned to halve the effective output. Alternatively neutral density filters may be placed over the flash tube or the camera lens. A neutral density of 0.3 halves the effective exposure, 0.6 gives quarter full output, 0.9 gives eighth full output and so on.

Some designs of automatic flash gun, when used in their manual mode of operation, have reduced power in halving steps from full to as little as 1/64 of maximum output. The flash duration shortens accordingly. This feature is useful for close-up work in various ways.

Reduced output is usually necessary due to the proximity of the flash to the subject. If exposure tests have been carried out at say 1/8 power for the flash at a set distance to find the ideal f-number for a low magnification. Then with the flash to subject distance and aperture kept the same and a required magnification of 0.5 the switch should be adjusted to $\frac{1}{4}$ power. For a magnification of 1.0 the switch should be at $\frac{1}{2}$ power. There is still power in reserve

for even bigger magnifications. So the lens aperture need not be altered to compensate for effective aperture if variable light output is available. Variations on this technique may be worked out for the other form of flashgun offering just full or quarter power.

Ring-flash units

Such flashguns are very simple and may have no form of calculator dial; it is assumed the user will carry out his own trial exposure and record the date for future use.

Because of their use, ring flashes have low light outputs compared with conventional units. Some do offer variable switching of output to half and quarter power.

Automatic flashguns

Recent advances in solid state electronics and switching devices have produced electronic flashguns that will automatically determine the correct exposure from measurement of the light reflected from the subject during the flash duration. This reflected light is monitored by a photocell and an integrating circuit which operates a special switch, termed a *thyristor,* to cut off the light from the electronic flash. Earlier designs diverted the remaining energy into a quench tube but later designs retain this charge. This arrangement permits very rapid recycling times and economic use of batteries.

It is important that the photocell be directed at the subject to monitor the reflected light. When the flashgun is shoe-mounted on the camera there may be parallax errors between the subject as seen by the lens and as seen by this sensor. So flash duration and exposure may be assessed from a distant background instead of the close subject.

When the sensor is pointed correctly at the subject, by means of a swivel arrangement or tilting device in the camera shoe, it takes an integrated reflected light reading of the subject. This works very well for the average subject, but some correction may be needed for the unusual subject.

Some automatic flashguns offer the feature of a remote sensor, where the photocell is mounted in a small probe unit connected to

the flashgun by a cable. This allows the flash to be used in modes such as bounce, or from the side rather than front. Other designs have swivelling flash reflectors with the sensor always directed towards the subject.

The remote sensor is useful in that it can be positioned to read just from the subject. If it is too close however, exposure errors can result from the reaction time of the circuitry being longer than the required duration of the flash. This problem of overexposure can be avoided by reducing the flash power output or by using a diffuser.

The problem of the effective aperture of the lens and its compensation to allow for magnification must still be considered, even with automatic flash guns. To operate the simplest automatic units, you set the film speed and they then indicate a lens aperture, say f5.6. The unit can then be used over a flash to subject range of say one to four metres (three to 13 feet). For a magnification of 0.5, half life size, the lens must be set to f4 instead of f5.6 to compensate for the change of effective aperture. This aperture may not give sufficient depth of field or lens performance. It is then best to use the flash in the manual mode and run exposure tests.

More advanced flash units may offer a choice of two or three different apertures depending on the power output selected and film speed. Others offer a continuous choice of aperture with a four or five stop range, the extremities of which are determined by film speed. This is often called a zoom feature, although the analogy to a zoom lens is misleading. This latter arrangement can be most convenient, allowing selection of an ideal aperture once allowance for image magnification has been made. It also allows fractional aperture corrections to be made instead of trying to set these on the aperture ring of a lens. The variable output feature mentioned above is often available for such flashguns.

Special Cameras and Equipment

The need for special equipment

So far we have looked at various items of equipment for tackling close-up photography, with the emphasis on the simplest items and minimum expenditure.

The techniques of obtaining and positioning the subject matter and the necessary care in lighting are often time-consuming and require considerable patience. The amateur photographer is happy to take such time and care, as well as make or devise items of equipment. The busy professional photographer, scientist or naturalist, requiring similar close-up records, usually cannot spare as much time. This is especially true if there are a large number of items to be recorded or if this has to be done on a routine basis. Instead, they are happy to invest sums of money, which can be considerable, in specialized cameras or pieces of equipment.

Such cameras may be in fact very simple to use, often with fixed magnification, pre-set lighting and fixed exposures to give an acceptable, if not quite perfect, result every time. Consequently large numbers of exposures can be made, or the same exposure conditions repeated time after time, often over an extended period of time.

The items described in this chapter represent some of the better known and more useful items, but only a brief outline of their characteristics and operation can be given. More information can be obtained from the specialist retailers or manufacturers.

The Medical Nikkor Lens

The Medical Nikkor lens is an unusual and unique lens made by Nikon. It has a focal length of 200 mm and a maximum aperture of f5.6. Originally, it was designed for routine clinical photography

with virtually fool-proof operation over a wide range of subject situations.

The basic lens is of fixed focus at approximately 3.3 metres (11 feet), giving a reproduction ratio of 1:15. It cannot focus at further distances. The long focal length allows a useful lens to subject distance and a pleasing perspective.

The lens has no focusing mount as such, instead a set of six supplementary close-up lenses are supplied for screwing in front of the lens. They may be used singly or in pairs to give exact reproduction ratios from 1:8 to 3:1, that is magnifications from 0.125 to 3.0. The subject is sharply focused for each setting by altering the distance of the lens and camera from the subject. No exposure corrections are necessary and a colour coding system on the supplementary lenses enables the correct aperture to be selected for exposure by the built-in ring flash.

This ring flash surrounds the lens and is an integral part of the mount. To assist focusing in poor light, four small incandescent lamps are provided as modelling lamps. Power is supplied from a mains unit or a battery pack. The flash output may be varied according to the magnification and aperture required. The lens stops down to f45.

A further refinement is the ability to imprint either a reference number or the magnification on to each frame as it is exposed. This is achieved using light bled from the main flash; there is also a brightness control to allow for various film speeds.

After consulting simple instructions, almost anyone is capable of using this lens to produce correctly exposed close-up photographs at a known magnification.

Lenses for macrophotography

The so-called macrolenses (see page 59) normally focus down to life-size magnification and have an automatic iris allowing full aperture focusing and exposure measurement. For really critical work in the difficult magnification range of 1.0 to 25.0 such lenses are often inadequate, even when used reversed.

Instead, special lenses for macrophotography give optimum performance in this range. They are manufactured by a few lens

makers including Zeiss, Leitz and Nikon. A typical range is the Luminar set of lenses made by Zeiss, with focal lengths of 16, 25, 40, 63 and 100 mm and maximum apertures from $f2.5$ to $f6.3$, depending on focal length.

Such lenses are stripped to the barest essentials. They have a simple screw mount fitting, often suitable for use on a photomicroscope using the standard RMS screw thread. They cannot be used as the objective in the usual two-stage magnification system of photomicrography, but only in a single stage imaging directly on to the senstitized material.

No focusing mount is provided for use on a camera, instead extension tubes or bellows must be used. Alternatively a technical camera or universal photomacrography camera may be used. As a further limitation to their use, the lenses are designed to give optimum results with a bellows extension of some 250 mm. So to obtain a given magnification the necessary focal length must be chosen for this extension, hence the available range.

The usual subjects have little depth so optimum results are given at full aperture, but stopping down is possible to increase depth of field although performance suffers. A simple iris diaphragm is fitted which is not calibrated in aperture values but merely in exposure increase factors with maximum aperture as value one; stopping down thus gives a series 1, 2, 4, 8, 16 etc.

Such lenses are expensive to buy, not easy to use and do not fit on to every camera. Nevertheless, they are highly esteemed as giving the ultimate in performance within their design specifications. Certainly in the difficult macro range of up to ×25 when low power microscopy is then possible and preferred, they are without equal.

The Zeiss Tessovar lens

In the macrophotography region, the most time consuming task is probably the framing and focusing of the subject at a desired magnification or the determination of the exact magnification in use. The Zeiss Tessovar lens is designed to overcome these problems. Basically it is a five element Tessar style zoom lens fitted with three additional supplementary close-up lenses in a turret. The lens

can be used with almost any still or movie camera, or with film backs alone.

Taking the case when it is used with a 35 mm camera, the three colour coded supplementary lenses give three fixed working distances of 150 mm, 75 mm, and 36 mm, with magnification ranges of 0.8 to 3.2, 1.6 to 6.4 and 3.2 to 12.8 respectively. The subject field covered correspondingly alters from 30 × 44 mm down to 2 × 3 mm.

The convenience of having a fixed subject distance as the magnification is changed and focusing stays constant, is very great. The magnification is read from a dial.

Additionally, the magnification setting is interlocked with the aperture setting so that the exposure correction factor is constant over the range.

The relative aperture of the lens varies from $f30$ to $f125$ and the effective aperture at any setting is the best compromize between depth of field and resolving power.

A prism reflex finder can be fitted for focusing and framing and has provision for a CdS cell so that exposure can be determined both quickly and efficiently.

Macrophotography stands

Massive camera stands for macrophotography and photomicrography are made by several manufacturers. Notable examples are the Leitz Aristophot and Nikon Multiphot.

As is usual with such equipment, the arrangement is of a systems design with a variety of interchangeable components available for various tasks.

The basic component is a large, heavy stand consisting of baseboard and uprights. Precision engineered, the stand carries a guide rail on to which one of a selection of very long bellows extensions are fitted. The guide rail may be bodily raised or lowered and the bellows length adjusted by a separate focusing arrangement. For macrophotography, a suitable lens and shutter are fitted together with the film format required. A mirror reflex housing is used for eye-level focusing.

Small lamps of the microscope type are used for episcopic (top)

illumination and for transillumination a special diascopic unit is used with a range of condensers and inserts.

Alternatively, a microscope may be positioned on the baseboard and the image projected on to the film format in use. A long bellows, shutter and light baffle are needed, plus the mirror reflex housing.

Exposure may be calculated from spot photometer readings of the ground glass screen of the viewfinder.

Such stands are far superior to alternative set ups using camera tripods and so on, being almost vibration free. Their main disadvantage is their relatively high cost.

Copying stands

A number of simple copying stands are available consisting in the main of a baseboard plus upright column. Alternatively an accessory arm can be used on an enlarger. While such arrangements are usable they are unable to compete with a sophisticated copying stand as typified by the Leitz Reprovit IIa.

Its basic design is of a large baseboard and massive column with a counterbalance arrangement for the camera head. Ordinary Leica camera bodies can be used, but the simplified Leica MDa is preferred, lacking viewfinder or rangefinder.

The camera is fitted to a sliding plate at the top end of a long bellows extension, calibrated for continuous reproduction between 1:20 and 1:1 with a special 50 mm lens. In the taking position the lens is stopped down its optimum value of $f11$, the four fixed position copy lamps are on and exposure made by magnetic release or by a timer on the lamps. After exposure, the film is wound on by the lever on the camera, then the camera is slid over to the focusing position. On doing this, the main lamps go off, the lens opens to full aperture and a projection lamp goes on. This lamp illuminates a screen with markings and scales exactly in the plane normally occupied by the film in the camera. By projection on to the subject the exact area to be copied is selected and also focused. Sliding the camera into the taking position switches off the projection lamp and the main lights on etc. In practice this is a very fast system.

This versatile instrument can be used for both close-up photography

Special equipment. A. The Bowens Texturelight ringflash with switchable quadrants. B. The Medical Nikkor 200mm macro lens. C. An enlarger used as a copy camera and equipped with copy lights. D. A macro lens in use on an extension bellows system with a microscope lamp for illumination.

and macrophotography. A variety of accessories such as extension tubes, lenses and viewfinders are available.

A special version is produced for microfilming.

Fibre optics light source

The problem of lighting very small subjects has been discussed (see page 94), with the main problem being the exact positioning of light sources close to the subject when the lens is also very close. In addition, incandescent lamps can cause heat damage.

A special light source for close-up photography is a flexible fibre optics tube, consisting of a long bundle of very thin glass fibres, conducting light from a distant intense source to the subject. This source is usually a tungsten-halogen lamp, enclosed in a box with a blower cooling system. A lens images the filament on to the end of the fibre optic connected to the box. Neutral density filters give variable intensity. Light is conducted down the glass fibres by total internal reflection and the length of glass acts as a very effective heat filter.

Semi-rigid external sheathing allows exact positioning of the free end of the tube which forms an intense source of light. One or more fibre optics sources may be used from one light source, thereby making 'multi-lamp' arrangements possible. They are light, small, easily positioned and have a high output. There are no heat or colour temperature problems.

Some Close-Up Subjects

Plant and flower photography

Apart from prize blooms and specimens of different types at shows, the yearly cycles of plant life in bud, full bloom or flower and autumnal tints can always be relied upon to provide interesting photographs. Close-up photography really comes into its own for this type of subject. A general photograph of a whole flower bed or clump of flowers is usually disappointing as the result tends to be a muddle of detail or a riot of colours. The close-up range from one metre (three feet) distance to life size reproduction means that it is easy to go from a general view of a flower to detailed shots of separate leaves, buds and heads of flowers.

The task of photography divides neatly into two categories: the problems of location photography and those of the studio. In most instances, if possible, carrying a plant indoors for photography eases many problems.

Location photography

For photography in the field, as it were, the best specimens always seem to be in shade under trees, or in marshy ground surrounded by obscuring grasses or rubbish. Of course, they are usually not very high off the ground. In addition, to aggrevate matters, conditions are often windy, causing swaying and movement of the plant. This makes focusing difficult for any sort of photography but particularly so for a close-up and securing adequate depth of field in such situations can be a matter of chance.

It is a good idea to use a small tripod for the camera and a plastic sheet to kneel upon. Carefully prune away excess foliage and insert a plain card or paper background for the flower. A clear plastic sheet suitably supported can usefully act as a windbreak but not

block out light to the subject. Problems of inadequate light and the resultant shallow depth of field at the necessary large apertures, plus the subject movements can all be solved by the use of electronic flash as the main light source. The flashgun can be used on its own or in conjunction with daylight. A simple reflector to lighten or illuminate shadows is also a great help. Details of all these techniques may be found elsewhere in this book.

The closest focusing distance on the majority of lenses is usually adequate to record the whole extent of most plant specimens, including clusters of leaves or blooms. A close-up lens allows individual blooms to be portrayed but extension tubes or bellows are needed to get details such as buds, small flowers, individual petals and other botanical details of interest. Many flowers have extended depth and the greatest problem is usually getting adequate depth of field. Fortunately, it is usually acceptable that the rims can be out of focus if the central region is sharp. The marked translucency or transparency of petals and leaves plus fine hair line growths or thorns are best shown by some form of back-lighting to supplement the main frontal illumination. Sometimes it is possible to choose a viewpoint that places the subject against a bright background.

Studio photography

When a flowering plant is brought indoors for photography, many of the practical problems detailed above will diminish or vanish. A good specimen should be chosen that is free from insect damage and with an ideal display of blooms or typical arrays of leaves. It may be positioned and supported at a suitable working height and the lighting arranged to give top and frontal illumination, so as to simulate sunlight conditions. The hue and saturation of colours are also emphasized by this form of lighting. If needed, backlighting can be arranged to silhouette shape and show details in translucent structures. Care must be taken when using tungsten lighting so that the flowers do not wilt; so switch off whilst you are not setting the lighting or exposing.

The camera can be on a tripod permitting long exposure times at small apertures, giving extensive depth of field. Even when using

electronic flash, the precise focusing needed for close-ups makes a tripod essential as a slight change in camera viewpoint can seriously alter composition and focus. Backgrounds can be black or white or of a colour complimentary to the specimen. For example, a green background suits red flowers. Often a blue card can be used with a low viewpoint so as to simulate a blue sky. Separate lighting may be needed for this background.

A series of pictures taken over a period of time can substitute as a form of time-lapse photography and may record, for example, the opening of a bud to full bloom or gradual colour changes in the specimen. It is important to keep lighting, exposure, films and so on as much the same within each series of photographs.

Apart from the usual wild and domestic species of flowers and plants, many other natural history subjects may be photographed in close-up including fungi, grasses and mosses. Most of these are best recorded in situ.

Domestic pets

Only too often a photograph of a pet shows the animal in the centre of a large expanse of lawn or carpet. A close-up picture is much more appealing. Most pets are fairly small, certainly compared with their owners, and can be photographed from closer range. The consequential distortion of features, unacceptable for portraits of people, does not detract from the appeal of the picture. A head shot of a dog or a cat is usually possible with the aid of a one-dioptre close-up lens or a short extension tube. Sometimes the closest focusing distance of the unaided lens may give a usefully large image, provided it focuses down to about 50 cm (20 inches). Electronic flash is the preferred light source in the absence of adequate daylight. Most animals are wary of bright incandescent lights and their pupils narrow due to their intensity. While a single source is usually adequate for most pictures, it is best angled or positioned to give top and side lighting so as to show texture. A fill-in light may be needed in such cases, even if only a sample reflector. Alternatively, the soft, diffuse light from bounce or umbrella flash may be preferred.

Depth of field problems are eased by the use of flash giving smaller

apertures. Also, subject movement may be frozen and the camera can be hand-held for 'tracking' a restless subject.

For big close-ups or when using large apertures needed for low light levels, it is best and easiest to focus on the eyes; the reflected highlights being good focus points. A low viewpoint is often needed as most animals are not very tall and some form of right-angle viewfinder may be a great help to avoid lying on the ground. The twin-lens reflex camera is ideal for photographs taken at or close to ground level.

Smaller pets, such as mice and hamsters need at least a three-dioptre close-up lens or extension tubes to give about one fifth life-size or a magnification of 0.2. At this close viewpoint there is very little depth of field, and whiskers appear out of focus unless the animal is photographed head-on. As before, flash is the preferred light source for indoor photography.

Birds

Cage birds pose problems because of their timid nature as well as their small size. Also, if the bird cannot be uncaged without uncontrolled flight taking place, the cagewires may spoil a good photograph. Many birds will sit happily on perches and pleasing profile shots are possible as they cock their heads to one side to view your proceedings warily. This side view approach helps overcome depth of field problems, at such close ranges. Once again, flash is a great help, and a three-dioptre close-up lens or extension tubes will be needed to fill the frame.

Some zoos offer spectacular opportunities for close-ups of birds, and sometimes it is possible to enter large enclosures full of exotic birds which feed at conveniently sited supplies.

Close-up photography of garden birds or wild birds is fraught with problems. In the absence of a hide for close-ups by long-focus lenses, a remote control camera may be left pre-focused on food, suitably concealed and fired when the subject appears. Nestlings are obviously static and may be photographed by flash after suitable pruning of the surrounds. But always beware of frightening the parent birds from returning or of leaving the nest exposed to predators.

Butterflies and moths

Flying insects such as butterflies, moths and dragonflies make ideal subjects for close-ups with the added thrill of hunting the subjects in the wild. For pictures of perfect, docile specimens, there is little choice but to rear the subjects at home and to photograph them under studio conditions. This is a hobby all on its own and series of photographs can be taken to show emergence from the chrysalis and so on. Wild butterflies are elusive and most species are only found in certain regions on specific plants and at certain times of the year. Study of their habits is a great help. Most specimens seldom have a wing span in excess of a few inches so at least a three dioptre close-up lens is needed or sufficient extension to give a magnification of about 0.3 to 0.5.

It is best to preset magnification and obtain sharp focus by moving the camera bodily into range, and be ready to fire as soon as both sharp focus and good composition is achieved. Usually, only one exposure is possible as the consequential noise, vibration and wind-on movements startle the subject. Occasionally, they may be completely pre-occupied with feeding and ignore the photographer. Some specimens keep their wings out when landed and others fold them up, so that a square-on or profile picture respectively gives sharp rendition within the limited depth of field. Flash is the ideal light source, especially if synchro-sun techniques are used.

Moths are nocturnal insects but can be lured to the photographer by using certain light sources. Often moths are found completely static in daylight on trees and walls, making perfectly behaved subjects for leisurely close-up photography. As with butterflies, antennae are prone to go out of focus by protruding out of the depth of field zone.

Other insects

Most other insects, such as spiders and beetles, are small and the close-up range from one-half to full life size is most useful. A macro lens in conjunction with an SLR camera and electronic flash is a useful combination. The very limited depth of field at such close ranges means that viewpoints must be chosen very

carefully; usually shots from above are best. Spiders with small bodies and long legs are often difficult to portray.

Details of small insects usually need a magnification greater than life size and the technique of macrophotography plus abundant patience are needed.

Fish and aquaria

The keeping of tropical or exotic fish and small reptiles in aquaria is a popular pastime and the beautiful displays, shapes and colours of such subjects are ideal for colour close-up photography. Most of the specimens usually kept are small, seldom exceeding a few inches in any dimension. In addition, they are usually narrow in cross-section and may be almost transparent or translucent enough to show details of internal organs. Such examples are ideally lit with back lighting or back plus top lighting which will also show details of spines, tail, dorsal and ventral fins.

The subjects are constantly moving in and out of the shallow depth of field zone given by the camera lens. A close-up lens of two or three dioptres is needed to give sufficient detail. Alternatively, an extension tube or bellows to give magnification in the range of 0.2 to 1.0 may be ideal.

A clean glass tank gives better optical quality than a plastic one. It is also a good idea to limit movement of the fish to the depth of field zone by inserting a glass partition; the picture is taken when the fish enters the field of view of the lens.

Again, electronic flash is the best light source because it arrests the movement and also does not overheat the tank or cause glare. The camera, preferably on a tripod, should have its lens viewing through an aperture in a piece of black card in front of the tank. This eliminates reflections from the tank's surface. A black card at the rear can also serve as a background. Suitable positioning of light sources at the sides or above and behind the tank can give a form of dark field lighting (see page 119), ideally suited to translucent subjects.

Reptiles and amphibia, including frogs and lizards are more static subjects, often remaining immobile for long periods. Usually big close-ups of features are most interesting, but remember to always

get the eyes sharply in focus. A long-focus lens used on an extension bellows gives good perspective and is less disturbing to the subject.

Close-up portraits

The term portrait is usually taken to mean a head and shoulders picture of the subject, but it also can include what is really environmental portraiture, that is, a picture of the subject in his usual home or work surroundings. By a similar extension we may consider close-up portraits as pictures that concentrate on the facial features only.

Most portraits are taken with longer focal length lenses to give a pleasing perspective, and a more distant viewpoint. Unfortunately, most of the lenses do not focus close enough for a close-up portrait. One way of overcoming this is to use a fractional dioptre close-up lens with very long focus lenses, or a one or two dioptre lens with moderate telephoto lenses. Exposure calculations are not changed with these attachments, a considerable advantage. The other method is to use extension tubes or bellows to bring the nearest focus point down to one metre (three feet) or less. In both cases, accurate focusing and framing are essential. The SLR type of camera is the ideal tool for the job.

One subject where facial distortion, due to close viewpoints, becomes acceptable is that of the baby or child portrait. The roundness of a baby's face, its small button nose and general lack of character features, means that you can go in very close with even a standard lens. The resulting pictures will show no unpleasant perspective. The handling of the subject is entirely another matter and much film might be wasted with an active child who moves like lightning out of focus or out of a tightly framed shot! It is advisable to use a fast film, since this means that fast shutter speeds and small apertures (large f nos.) can be used. The net result is less subject movement and focusing is less critical.

Unpleasant perspective is reduced by a profile view, but it is essential to focus the eyes sharply irrespective of the viewpoint. Close-ups of just the eyes, combined with or without other facial features can give very good pictures.

Craft photography

There is always a ready market for the kind of illustrated do-it-yourself articles found in many craft magazines. Also, close-up instructional photographs will improve any lecture to a local institute or club. Local newspapers are always interested in craft exhibitions and the big close-up, concentrating on detail, is usually well received.

Most instructional series of photographs consist of close-up photographs and a few general shots. These general shots serve to 'set the scene' and summarize the results. Otherwise, medium and big close-ups show specific items, methods of use, positioning of fingers, poor and good results, progress of the treatment, technique and so on.

Planning your shots is the secret of making a good sequence of photographs and the story board technique may be borrowed and adapted from its role in film making. The job is broken down into significant or important stages, and one or more shots are taken to illustrate each stage. All unwanted detail must be excluded from each shot. It is often convenient to take all shots of similar magnification at the same time, especially when complex close-up aids are used.

One point to remember is that hands look swollen or mis-shapen if viewpoint is too near, or if they occupy too much of the frame. Also, they must be scrupulously clean and well manicured as any imperfections are only too obvious. Soft lighting is a help.

Scale models

The careful building or assembly of accurate scale models in card, plastic or wood and their use in, for example, model railway layouts, is another hobby giving considerable scope to close-up photography.

Normally the viewpoint of the camera lens is chosen to simulate an eye level view of the full size subject. For example, a model railway engine may be photographed with the camera lens positioned halfway up its vertical height! A useful alternative is to choose a low viewpoint and paint a piece of blue card with white clouds to act as

a background; this appears quite realistic when the background is out of focus.

A lens of suitable focal length can be chosen so as to include the subject as required. For instance, a room in a dolls house is all included by a 24 mm lens on a 35 mm camera which also gives a natural viewpoint. Most lenses of this type focus down to 30 cm (one foot) unaided and when well stopped down will render the miniature room sharp. The usual scale of dolls houses is one to 12, that is 25 mm (one inch) represents 30 cm (one foot).

Scale models of aeroplanes may be photographed from slightly above when parked on concrete or tarmac to simulate an airfield runway or dispersal point. The usual scale for these models is 1/72. A more ambitious method is to photograph them as if in flight, suspended on one or more thin black threads to prevent rolling during exposure. As before, blue card with patches of white sprayed on, can simulate a sky background.

In general, the lighting on such subjects should simulate bright sunshine. So the light source needs to be positioned above the subject with fill-in lighting as required. Architectural scale models for railway layouts may benefit from lower side lighting so as to enhance detail.

A two or three dioptre close-up lens is useful for such photography, as the lens will be stopped down for depth of field and therefore produce good definition. The direct, parallax free viewing of an SLR camera is very useful as an aid to selecting the ideal viewpoint as very small changes in camera position make big differences in perspective.

Coins and medals

Coins, medals and similarly shaped jewellery are common examples of shiny metal objects with surface details and patterns in low relief. Such subjects give very satisfying close-up pictures but pose a few problems all of their own as regards photography.

Most coins are fairly small in size, usually not exceeding 5 cm (two inches) in diameter. They are best photographed at or near life size as the film format permits. The common 24 × 36 mm and 60 × 60 mm film formats have very convenient dimensions for this

task. Sometimes it is necessary to include a suitable scale or recognizable object to indicate the true size of the subject.

A close-focusing or macro lens is ideal for this sort of photography, but a lens on extension tubes or bellows is a good second choice. Close-up lenses even of three dioptres do not give enough magnification; a power of ten would be needed but such lenses are not readily available. The depth of field given at such close distances for once is not really a problem as the shallow relief of the subject is usually less than the zone of sharp focus.

It is important that the subject is square on to the camera, otherwise a circular coin becomes distorted to an elliptical shape. Careful alignment by eye in the viewfinder is needed; this is helped by the use of a cross-line screen.

The lighting of these reflecting subjects is quite tricky. A very oblique, large light source such as a floodlight will give soft shadows and depth to most of the surface detail. A spotlight gives exaggerated detail and deep shadows requiring an additional fill-in light or reflector. Very shallow relief in the subject may require axial lighting to show detail (see page 113). Alternatively, a light tent arrangement gives diffuse light and subdues surface reflections. Full descriptions of each of these techniques are given in the lighting section of this book.

The subject may be placed on a plain background of a contrasting tone or colour, and raised up from this by a small block of wood or plasticine. Care must be taken to avoid the support being visible. The subject stage, available as an accessory for many extension bellows, can be an ideal platform as alignment is already fixed. Using a translucent stage plate and rear lighting can simulate a light box as your background. This arrangement can be used to remove cast shadows from the main lighting, as the light box intensity can be varied to give a uniform white background when printed or viewed.

Light meter readings can be made from a grey card or by an incident light reading. Because of the small size of the subject compared to a light meter cell, a reflected reading may be inaccurate. The necessary exposure increase for lens extension must not be forgotten.

Through-the-lens metering, especially if of the small area or centre

weighted variety, usually gives an accurate indication of exposure including corrections for magnification.

Close-ups and abstracts

One of the most rewarding and intriguing aspects of close-up photography is the production of abstract pictures. Abstract pictures in this sense are ones which depict no immediately recognizable subject or form, but have random or irregular arrangements of pattern, tone and colour, in a pleasing or satisfying manner. Perhaps a very simple example is a lens focused at its closest distance but used to image a distant subject such as the light shining through tree branches. The juxtaposition and over-lapping of the out of focus highlights and colours of the subject can give very pleasing photographs. A large aperture is best to ensure minimum depth of field, and an SLR camera viewfinder system aids precise composition. The reject rate tends to be high in abstract photography!

Many photographs that are sharp, in-focus big close-ups can in themselves be very pleasing as abstractions.

For example, the glazing and cracks on ceramics, the tool marking on metal surfaces, printed surfaces, the texture of flower petals or leaves and so on.

Yet another approach is to photograph small objects which have marked optical properties. A big close-up of raindrops on a window pane, for instance, will show that each one images sharply the background but upside down. Also, drops of clear oil on a glass plate with a variety of line or colour patterns acting as backgrounds, can give very interesting results. On similar lines, many clear glass or plastic objects such as patterned, etched or dimpled drinking glasses can provide exciting imagery. Some years ago, a well known photographer produced many pure abstractions in colour from irregular lumps of optical glass by photographing in close-up the irregularities and flows in the body of the glass. Many clear plastic objects transform into beautiful colour patterns when viewed through a polarizing filter. If the light source is also fitted with a polarizing filter, low grade optical quality sheet material is adequate, then innumerable colour variations are possible by rotation of the

pola filter over the lens. These effects are due to the refractive properties and residual manufacturing stresses in the plastic.

If a single exposure does not give a very interesting picture or if the subject lacks colour, then multiple exposures can be tried. Many cameras permit the double exposure prevention device to be overridden and the shutter re-set for multiple exposures on one frame of film. Possible variations include moving a single light source between exposures and the use of different coloured filters over the light source or camera lens for each exposure. Such additive colour synthesis gives yellow from red and green light overlaps, coloured shadows and unreal appearance. Exposures are calculated as normal and one stop increase given for the use of a red, green or blue filter. The result integrates to approximate correct exposure when a triple exposure has been made. The subject may be moved during a short time exposure to further blur and integrate colours.

A great advantage of this form of abstract photography, like most other forms of close-up photography, is that very little space is needed. An earlier description was *table-top* photography which fits the situation exactly.

Translucent and transparent subjects

Many close-up subjects come into this category, including both natural and man-made subjects from leaves to glass as well as animate subjects such as fish.

Frontal lighting is not always suitable for such subjects as they are also usually highly reflective and the reflex images of light sources can be distracting and hide important detail. The best technique is to light predominantly from behind so as to show detail as well as the translucency of the subject. Even better may be a mixture of top and side lighting to show the edges of the subject in sharp outline as well as internal details.

The choice of background tone, either light or dark, gives what is termed bright field or dark field lighting respectively (see page 119). Dark field is usually best for both coloured and colourless subjects and the lighting contrast shows up the smallest details and increases colour saturation.

172

Copying techniques

A standard request to any amateur photographer, sooner or later, is to copy by photography a document of one sort or another. In addition, most people own documents, certificates and other printed ephemera of various sizes, quality and rarity of which they would like to have a record, if only for security purposes. Other typical subject matter for copying is illustrations and diagrams in books, usually to produce a slide to illustrate a talk or lecture. All such subjects may be considered under the general heading of copying techniques. One word of caution, however, before describing the usual methods, is that concerning the copyright of the original document. There may be legal restrictions on photography of many items without written consent from the copyright owner. Items such as banknotes and legal documents require special permission, so be warned.

The advantage of a good copy made by photography, rather than one given by an electrostatic office copier, is that the contrast of the copy can be adjusted to suit the subject. If the original is of continuous tone, such as a photograph, then it can be reproduced as such and not as a soot and whitewash copy. In addition, an old and faded original may be enhanced in a copy by increase of contrast and judicial use of colour filters to remove stains and marks. For example, a yellowed (but not stained) photograph is improved by copying through a blue filter onto conventional panchramatic film or alternatively, a blue sensitive material of fairly high contrast. Obviously, if the original is a line diagram, that is contains no midtones, then a suitable film and developer is used, such as lith film and lith developer.

A common property of most originals likely to be encountered is that they are flat or with a low relief, such as an oil painting or engraving. Consequently, lighting is needed that subdues shadows and is even all over in intensity. So called *flat copy lighting* is described fully on page 120.

The usual size range of documents is from foolscap or A4 down to ordinary postage stamps. The larger items can usually be made to fill the frame at the closest focusing distance of normal lenses. The lens should be well stopped down to say $f11$ or $f16$ to ensure

good overall sharpness. Originals down to about postcard size may be copied with the aid of close-up lenses. A +3 dioptre value is about the strongest that should be used. For smaller subjects an extension bellows or tubes may be needed. The ideal copying lens is a macro lens with continuous focusing down to life size, retaining excellent performance.

Great care is needed to ensure that the whole document is included in the film frame and that it is recorded square-on to the camera. It is best to use a spirit level to align the camera and subject correctly. If you are doubtful about the accuracy of your view-finder, do some simple tests to determine the exact field of view and area included and any parallax correction required. Any subject with regularly ruled lines will serve as a test object.

For copying from books or bound volumes in libraries or on location, a copy pod or copy legs device is unsurpassed for rapid alignment of the camera with the subject and accurately delineating the subject area in the plane of sharp focus. Shadows from the legs can be a problem sometimes.

Depth of field is no problem, even for life size copying of stamps, as the flat original is easily accommodated within a narrow zone of sharpness. The static nature of the subjects also means that long exposure times can be given using the B setting of the camera, or even by switching on and off the copying lights. This is usually the method adopted when an enlarger is used as a close-up copy camera by replacement of the usual negative carrier with a special film cassette. Alignment is no problem and a focusing negative is used to obtain focus and subject area covered, then it is replaced by the copy film.

One effect of the heat emitted by the copy lights can be to cause the originals to curl or move during exposure, so some means of holding them flat is needed. Care must be taken when using sticky type so as not to damage the original. A vacuum easel is a luxury item. One easy method is to use paper or card strips down the edges and held in place by pins.

Selected areas of the original can be isolated, as in the case of a diagram in a book, by the use of two L-shaped pieces of black card which are overlapped to give the required square or rectangle. Neat black borders are given in the copy, which is especially

important for slides; thus avoiding 'spill' illumination on the screen. For continuous tone originals such as photographs, the exposure necessary can be measured by the usual reflected light techniques or through the lens metering. For monochrome originals the aim is to get a negative of moderate contrast but greater minimum density than usual. This is then printed as normal. A large negative format helps retain quality. For line originals a series of test exposures are needed. Notes should be kept of the optimum exposure conditions as they can be used again in the future.

Many originals have a pronounced colouration or are printed in colour. Examples are old maps and illuminated manuscripts. Obviously colour film is required and the correct light sources must be used; that is artifical light film with photoflood lamps. Care is needed to ensure that the intense heat and light do not damage originals.

Copying colour slides

Another frequent need is to copy a colour slide to make a duplicate transparency, or a monochrome negative or a colour internegative so that prints can be produced.

An original colour slide is a flat, coloured, translucent object of negligible thickness, and therefore depth of field problems at life size reproduction are negligible. Often the transparency is fixed into a slide mount of plastic or card without any cover glasses. It is likely that previous projection has caused buckling so the transparency is best removed for remounting between glass or held in suitable masks.

Slides are usually copied at life-size or slightly larger to allow selective cropping to improve composition or match another format. A simple copying arrangement is to place the mounted slide in a suitable aperture in an opaque black card with the camera in front and the light source behind. A diffuser of flashed opal glass or similar material is needed behind the transparency or in front of the light source. Colour filters may be needed for colour correction depending on the colour film used. A tungsten lamp such as a photoflood can be used for both focusing and exposure with artificial light type film; electronic flash requires daylight film. One

of the very small one-piece flash units has adequate light output for the job and can be suitably positioned to allow a marked aperture of $f11$ to be used. This aperture gives good performance with close-up lenses or extension tubes. It is fairly easy to devise simple holders and distance pieces for the various components of the above set up. Alternatively, a variety of purpose built apparatus may be purchased for the job.

One of the simplest is a tube with a high power close-up lens in the middle. The tube fits directly on to the camera body and the slide is attached to the other end. The slide is illuminated by flash or by holding it up to a window. Alignment is no problem but the magnification is fixed at life size.

A transparency copying attachment is available as an accessory for most extension bellows systems (see page 58). Once again, this is a device for holding a transparency or individual roll of film at the correct distance from the camera lens which is on the extension bellows. A bellows type lens hood may clip on between lens and slide holder so as to exclude ambient light, which could cause trouble with flare. Illumination techniques are as before.

If expense is no concern, a special slide duplication machine such as a Bowens Illumitran may be purchased. This has refinements such as measurement of the overall density of the transparency, automatic exposure determination and contrast control of the copy by means of a supplementary flash.

One possible problem in colour slide duplication is that the contrast of the copy may be higher than the original especially for subjects with saturated colours. This may be controlled in various ways and perhaps the simplest for the amateur is to use one of the low contrast special slide duplicating films now available. Exposure for slide copying may be given by through-the-lens metering if a tungsten lamp is used for lighting and of course any exposure corrections for magnification are automatically allowed for.

If flash is used, a test series of exposures at different apertures or with the flash at different distances from the slide, will be needed. Use a slide of an average scene and after processing, select the best result and use the exposure data for this one as a basis for future work.

Finally, there is little doubt that a macrolens which gives life size

at closest focusing distance, is the ideal lens for slide copying both as regards performance and ease of use. A good second choice is to adapt an enlarging lens to fit on an extension bellows.

Data Section—Essential Tables and Formulae

The necessity for close focusing and the use of the various accessories needed for close-up photography also usually mean that some essential table of data has to be consulted. This may just be to obtain an exposure correction factor when the magnification is known. Alternatively the subject area covered or the depth of field at a certain aperture stop may be required.

All this information and much more besides can be worked out from first principles, by the use of the appropriate formula or from tables of selected data using the most common values found in practise. In this chapter, the latter two methods are both offered as choices. The various mathematical formulae for optics and exposure are given so that with the aid of a simple pocket calculator specific data may be determined. Then for convenient and speedy reference there are various tables of data.

Concerning the actual values of some of the data given, it may be found that they differ slightly from the corresponding values given by other text books or sources. This is to be expected and understandable for the final values depend upon the original data values used in the formulae. The depth of field values are particularly prone to variation depending on the value of the diameter of the chosen *circle of confusion* or blur circle.

In other cases the exposure correction factors suggested may not seem to be quite correct when the photographic results are viewed. This may be for a variety of reasons. Possibly the lens used was not of an approximately symmetrical design or the flash gun used was not behaving as an approximate point light source.

The tables can only really be taken as an initial guide or starting point which will cover a vast majority of situations. Your own practical tests, a careful log of exposure data and accumulated experience will soon provide your own reference data for your particular equipment and subjects.

Basic formulae

Most of the following formulae and equations have been defined, explained or quoted in the preceding chapters but it is useful to group them together. It should be pointed out that in some cases they are simplifications of much more complicated formulae, but because the approach has been that of the properties of a simple thin lens the simple versions are quite valid.

definitions of symbols used:

u lens to subject (object) distance.

v lens to film distance (bellows extension).

m image magnification or scale.

f focal length of the camera lens.

f_1 focal length of lens 1.

f_2 focal length of lens 2.

F focal length of a combination of two or more lenses.

d lens extension from the infinity setting in a focusing mount.

N the relative aperture of a lens (*f*-number).

N_e the effective aperture of a lens.

c diameter of the circle of confusion (blur circle) in the image.

C diameter of the blur circle in the final print.

M final value of magnification in the print.

s close-up depth of field in the subject symmetrical about the focus point.

S depth of field perceived in the final print.

k diameter of the clear aperture of the lens.

P power of a lens in dioptres.

P power of a lens combination in dioptres.

I image height or size.

O object height or size.

t exposure time in seconds.

T exposure time corrected for magnification.

1. The basic lens equation (conjugate relationship).
 $$1/u + 1/v = 1/f.$$
2. Image magnification. $m = v/u = I/O$

3. Useful relationships derived from one and two above.

$$u = f(1 + 1/m)$$
$$v = f(1 + m)$$

4. Lens extension needed to focus on a subject at distance u.

$$d = \frac{f^2}{u-f}$$

5. Power of a lens in dioptres when focal length is in millimetres.

$$p = \frac{1{,}000}{f}$$

6. Combined focal length of two lenses in contact, e.g. a camera lens plus a supplementary lens.

$$1/f_1 + 1/f_2 = 1/F$$

7. Combined power of two lenses in contact.

$$p_1 + p_2 = P$$

8. Relative aperture of a lens. $\quad N = f/k$

9. Effective aperture of a lens. $\quad N_e = v/k$

10. Correction to relative aperture for close-ups to give effective aperture.

 (a) $\quad N_e = N(1 + m)$
 (b) $\quad N_e = N \times v/f$

11. Correction to indicated exposure time for close-ups due to magnification.

$$T = t(1 + m)^2$$

12. Depth of field in the negative image.

$$s = \frac{2Nc(1 + m)}{m^2}$$

13. Depth of field in the print.

$$S = \frac{2NC(1 + M)}{M^2}$$

Tables of data

COMMON FILM FORMATS

Film type and width	Formats used (mm)
110 (16 mm wide)	13 × 17
126 (35 mm wide, unperforated)	26 × 26
135 (35 mm wide, perforated)	24 × 18, 24 × 36
120, 220 (62 mm wide)	60 × 45, 60 × 60, 60 × 70, 60 × 90
70 mm wide perforated	60 × 60, 60 × 70
Self-developing film	67 × 90, 78 × 78

The dimensions given are nominal, the true values are slightly smaller, depending on the make of camera.

IMAGE MAGNIFICATION WITHOUT ACCESSORIES

Focal length (mm) 24 × 36 mm format	Typical closest focusing distance (metres)	Corresponding magnification
28	0.3	0.103
35	0.5	0.075
50	1.0	0.053
50	0.5	0.11
105	1.3	0.09
135	1.5	0.1
200	2.0	0.11

60 × 60 mm format		
40	0.5	0.87
50	0.5	0.11
80	0.9	0.1
150	1.4	0.12
250	2.5	0.11

181

FOCUSING FOR 50 mm LENS WITH 24 × 36 mm FORMAT

Lens extension (mm)	Subject distance (mm)	Image distance (mm)	Magnification	Subject area covered (mm)	Exposure time correction factor
5	550	55	0.1	240 × 360	1.2
10	300	60	0.2	120 × 180	1.4
15	217	65	0.3	80 × 120	1.7
20	175	70	0.4	60 × 90	2.0
25	150	75	0.5	48 × 72	2.3
30	133	80	0.6	40 × 60	2.6
35	121	85	0.7	34 × 51	2.9
40	113	90	0.8	30 × 45	3.2
45	106	95	0.9	27 × 40	3.6
50	100	100	1.0	24 × 36	4.0
60	92	110	1.2	20 × 30	4.8
70	86	120	1.4	17 × 26	5.8
80	81	130	1.6	15 × 23	6.8
90	78	140	1.8	13 × 20	7.8
100	75	150	2.0	12 × 18	9.0
150	67	200	3.0	8 × 12	16.0
200	63	250	4.0	6 × 9	25.0

SUPPLEMENTARY LENS VALUES

Lens designation or combination (Dioptres)	Focal length (mm)
$\frac{1}{4}$	4,000
$\frac{1}{2}$	2,000
1	1,000
2	500
3	333
1 + 3	250
2 + 3	200
3 + 3	167

SUPPLEMENTARY LENS DATA

50 mm lens on 24 × 36 mm format

Focus setting (m)	Close-up lens (dioptres)	Magnification	Subject distance mm	inches	Subject area (mm)
∞	+1	0.05	1000	39	480 × 720
1	+1	0.11	500	20	218 × 327
∞	+2	0.10	500	20	240 × 360
1	+2	0.16	333	13	150 × 225
∞	+3	0.15	333	13	160 × 240
1	+3	0.21	250	10	114 × 171

80 mm lens on 60 × 60 mm format

∞	+1	0.08	1000	39	750 × 750
1	+1	0.17	500	20	353 × 353
∞	+2	0.16	500	20	375 × 375
1	+2	0.26	333	13	231 × 231
∞	+3	0.24	333	13	250 × 250
1	+3	0.35	250	10	171 × 171

150 mm lens of 60 × 60 mm format

1.4	0	0.14	1270	50	429 × 429
∞	+$\frac{1}{2}$	0.08	1956	77	750 × 750
1.4	+$\frac{1}{2}$	0.23	737	29	261 × 261
∞	+1	0.15	1016	40	400 × 400
1.4	+1	0.31	533	21	194 × 194
∞	+2	0.30	508	20	200 × 200
1.4	+2	0.48	343	14	125 × 125

DEPTH OF FIELD FOR 24 × 36 mm FORMAT

| Magnifi-cation | Reproduc-tion ratio | Depth of field at | | | | | |
| | | f5.6 | | f11 | | f22 | |
		mm	inches	mm	inches	mm	inches
0.050	1:20	157	6.20	308	12.10	616	24.20
0.062	1:16	102	4.02	200	7.90	400	15.80
0.071	1:14	78.4	3.09	154	6.06	308	12.12
0.083	1:12	58.2	2.30	114	4.50	228	9.00
0.10	1:10	41.1	1.62	80.7	3.18	161	6.40
0.11	1:9	33.6	1.32	66.0	2.60	132	5.20
0.12	1:8	26.9	1.06	52.8	2.08	105	4.16
0.14	1:7	21.0	0.83	41.0	1.62	82	3.24
0.17	1:6	15.7	0.62	31.0	1.21	62	2.42
0.20	1:5	11.2	0.44	22.0	0.87	44	1.74
0.25	1:4	7.5	0.30	14.7	0.58	29.4	1.16
0.33	1:3	4.5	0.12	8.8	0.35	17.6	0.70
0.50	1:2	2.2	0.09	4.4	0.17	8.8	0.34
0.67	1:1.5	1.4	0.06	2.8	0.11	5.6	0.22
0.75	1:1.33	1.2	0.05	2.3	0.09	4.6	0.18
1.00	1:1	0.8	0.03	1.5	0.06	3.0	0.12
2.00	2:1	0.3	0.01	0.6	0.02	1.1	0.04

The table above has been calculated for a circle of confusion of l/30 mm.

DEPTH OF FIELD FOR 60 × 60 mm FORMAT

| Magnifi-cation | Reproduc-tion ratio | Depth of field at | | | | | |
| | | f5.6 | | f11 | | f22 | |
		mm	inches	mm	inches	mm	inches
0.1	1:10	50	1.97	100	3.93	200	7.87
0.2	1:5	20	0.79	40	1.58	80	3.15
0.3	1:3.3	9	0.35	18	0.71	36	1.42
0.4	1:2.5	5.5	0.22	11	0.43	22	0.86
0.5	1:2	4.0	0.15	8	0.32	16	0.63
0.6	1:1.7	2.5	0.10	5	0.20	10	0.39
0.7	1:1.4	2.0	0.08	4	0.16	8	0.32
0.8	1:1.2	1.7	0.07	3.3	0.13	6.6	0.26
0.9	1:1.1	1.4	0.06	2.8	0.11	5.6	0.22
1.0	1:1	1.2	0.05	2.3	0.09	4.6	0.18
2.0	2:1	0.4	0.02	0.8	0.03	1.6	0.06

The table above has been calculated for a circle of confusion of l/20 mm.

EXPOSURE CORRECTION FACTORS—EFFECTIVE APERTURES

Magnification	Correction factor to f-number to give effective aperture. Multiply by:	As an example, approximate value of f11 set on lens
0.1	1.1	f12
0.2	1.2	f12
0.4	1.4	f15
0.6	1.6	f18
0.8	1.8	f20
1.0	2.0	f22
2.0	3.0	f32
3.0	4.0	f45
4.0	5.0	f64

EXPOSURE CORRECTION FACTORS

Magnification	*Approximate correction factor. Multiply exposure time by:	**Approximate correction factor. Open up aperture by: (stops)
0.05	1.1	0
0.1	1.2	0
0.2	1.4	$\frac{1}{2}$
0.3	1.7	$\frac{1}{2}$
0.4	2.0	1
0.5	2.3	1
0.6	2.6	1
0.7	2.9	$1\frac{1}{2}$
0.8	3.3	$1\frac{1}{2}$
0.9	3.6	2
1.0	4.0	2
2.0	9.0	3
3.0	16.0	4
4.0	25.0	$4\frac{1}{2}$

* These values are the correction factors for indicated exposure time, when it is required to keep the aperture at the set value.

** If you require to keep the time at the set value, then the aperture is opened up by the indicated number of stops.

Index